THE NO NONSENSE GUIDE TO TEACHING ART

BY
SARA BEGGS

ILLUSTRATED BY
LYNDA VOLAVKA
BASED ON THE ORIGINAL WORK OF
SARA BEGGS AND GIGI SIMOCKO

COVER DESIGN BY
MARGHERITA DePAULIS

Publishers
T.S. Denison & Company, Inc.
Minneapolis, Minnesota 55431

1

T.S. DENISON & COMPANY, INC.

"Materials designed by teachers, for teachers" is a statement that the T.S. Denison Company is extremely proud of. All of our quality educational products are tried, tested, and proven effective—by teachers!

For over 100 years, T.S. Denison has been a leader in educational publishing. Thousands of teachers look to us for new and innovative aids to make their work more enjoyable and more rewarding. We are committed to developing and publishing educational materials that will assist teachers in building a strong curriculum for young children.

Plan for great teaching experiences when you use materials from the T.S. Denison Company.

DEDICATION
To John, who made it all possible!

Standard Book Number: 513-02051-9
The No Nonsense Guide To Teaching Art
Copyright ©1991 by T.S. Denison & Co., Inc.
Minneapolis, Minnesota 55431

Printed in the USA

NO-NONSENSE GUIDE TO TEACHING ELEMENTARY ART

INTRODUCTION

The No Nonsense Guide To Teaching Art will provide the new inexperierced teacher, as well as the experienced teacher, with a wealth of ideas, techniques and activities for developing an exciting elementary art curriculum.

Not only will you find a multitude of projects for Special Education, Kindergarten through Grade Six and a section of projects for Gifted children, but you will also appreciate the huge variety of suggestions for:

- Scheduling
- Getting New Ideas
- Volunteers
- Room Layout
- Motivation
- Clean-Up
- Discipline
- Grading
- Collecting
- Art Exhibit
- Clay
- Art Bulletin Boards

Remember, each teacher will approach the teaching of art with an individual flair. Modify these projects and ideas to suit your own personality and needs. Above all, foster creativity and help your students enjoy art!

TABLE OF CONTENTS

TABLE OF CONTENTS

SCHEDULING

Scheduling can make or break any art teacher. If a principal gives you more than six classes a day your energy and enthusiasm will be drained by the end of the day. You need to let your principal know the importance of classes being long enough to prevent frustration on the part of the student. A class must be long enough for a student to feel relaxed while he is working on a project. This will relieve the pressure to finish in an allotted time slot that is too short.

An art class is not the same as other subjects. A considerable amount of time is spent on passing out supplies (scissors, glue, water, brushes, etc.). At the end of the class the room must be in good order for the class that will follow. Some essential preparations might include picking up scraps of paper from the floor, washing table tops, returning supplies to their storage areas, and getting material out and arranged for the next class.

Along with the maximum 6 classes a day, there must be at least 5 minutes between classes to allow for additional clean up and preparing material for the new class. Many times paper must be cut to specific sizes and new supplies set out. This 5-10 minute period of time is never "free time" but time spent that makes for a smooth running program.

The amount of time needed for each grade level varies according to age and attention span. Thirty minutes is the optimum amount of time that a kindergartner will remain interested in an art project or for that matter any activity. Do not attempt to accomplish an art project with kindergartners in thirty minutes without an extra pair of adult hands, an aid or volunteer (*see chapter on volunteers*).

First graders are able to remain interested for a longer period of time. For first grade, forty five minutes seems to be a good workable time frame.

From 2nd through 6th grade, an hour is needed to complete or "get into" an activity. A period of time shorter than this does not permit students to think, produce and evaluate what they are working on.

If you are given enough time in a school, it is exciting to set up a "special art" class. This class could be:
> a) A small group, i.e., twelve students which you would see once a week for 2 months until you have seen everyone at a certain grade level.
> b) Twelve "artistically gifted" students that you see once a week all year long.

GETTING NEW IDEAS: THE PROJECT SEARCH

Included in this book are some of my art projects to get you started in your hunt for new ideas. These are projects that I have done many times with classes. These have proven successful for me, yet don't expect anyone to select your projects. It's up to you. Finding art projects appropriate for your students is an ongoing search. In developing your personal art program do not limit your possibilities. The lessons cannot be and should not be restricted to projects you find in books like this. Art teachers are successful when they have the ability to come up with fresh ideas. An art teacher who does not regard the search for new ideas as an integral part of his teaching will become repetitive. You need to keep your program alive with a constant flow of new, exciting material. It takes time to build a bank of ideas.

Here are some lesson hunting strategies:
- subscribe to art publications
- go to art education conventions
- keep in touch with children's likes (tie-dying T-shirts)
- attend university art lectures
- go to art exhibits (adult and children)
- share ideas with other art teachers
- take an old art project and make it new by using a different medium
- visit art classes in nearby school districts
- go to the library

I have found it useful to put each lesson on a 3 x 5 card and file them by grade level. The most important thing is to remember that the project is not the goal, **the goal is the process of creating the project**. If the child enjoyed the creative process, you've achieved your goal.

VOLUNTEERS

An art teacher must work during a specific time period. Each class meets for a definite period of time that has been established by the school principal. At the end of one class another class may be waiting at the door. Try not to keep the teacher waiting as this will be the classroom teacher's planning time and he is eager to leave. Classes, according to grade level, will meet anywhere from 30 to 60 minutes. At the end of your instruction, the room must be made ready for the next scheduled group. Tables may need to be sponged off and materials will have to be prepared for the following group. I have found that parent volunteers are a valuable resource in assisting to make the clean up and preparation go as smoothly as possible.

At the beginning of the school year, I send home a form with each child. On this form I request parents to volunteer their services for a time that is convenient to them. (The majority of parents prefer to work with the class that their child is in.)

A sample form could look like this:

> *Dear Parent,*
>
> *I am requesting art volunteers to assist me with clean up and material preparation. Artistic talent is not a prerequisite! I am enclosing a class schedule and have circled the time your child has art.*
>
> *Please let me know if you will be able to help with any of the classes.*
>
> *Sincerely,*

Today, many parents work and won't be able to make the commitment, but I always have managed to have at least one parent per class. When more than one person volunteers for a particular class, I make up a rotating schedule.

Advantages of using volunteers:
1) Classroom teachers do not have to wait until the room is ready
2) Students enjoy seeing their parent in school
3) Parents feel like a valuable part of the school community

Disadvantages of using volunteers:
1) a few parents "hover" over their own child
2) Parents may make an inappropriate comment to a child
3) Parents may have a younger child who tags along

Suggestions:
1) Before the parent begins as a volunteer, thoroughly explain to them that they are there for all of the children
2) Explain to them that all of their comments must be positive in nature
3) Usually a younger brother or sister enjoys coloring on a large sheet of paper or trying his hand at the art project. If a child becomes disruptive, suggest that the parent take the child for a walk around the school and try again next week

I have found that this volunteer program has lifted a big weight from my shoulders. I don't feel as hassled at the end of the day and my room stays in a better state of order.

Room Layout

The potential for chaos is always around the corner in an art room. The physical constraints of doors, sinks and windows cannot be changed but there are ways to make an art teacher's life easier. Organization is a necessity, and you must make your room as functional as possible.

All kinds of room arrangements are possible but the one I find most effective is illustrated here. As an example, we will take a class of 24 students. For this class size you will need 6 large tables with 4 students at a table.

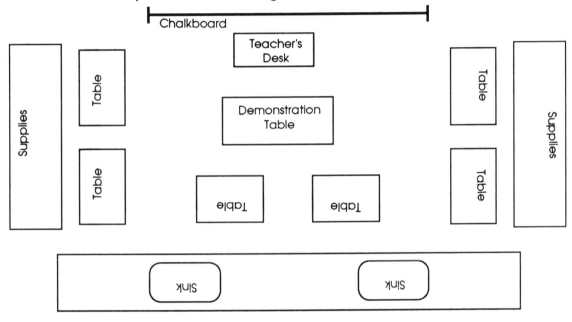

Six tables are grouped around a center table. The center table serves two purposes:

1) Demonstrating to the class. It's at this "center stage" that students can see project presentations close up.
2) A place to put supplies that are needed for that class's lesson. This location makes the supplies most accessible.

As you will use the blackboard frequently, be sure it is visible to all. Some students may need to turn their chairs to see the blackboard or center table and then face the table when they are ready to begin work. Frequently used art materials such as glue, scissors, crayons, erasers, a roll of tape and stapler should be stored in the same spot throughout the year. By doing this students always know where to go to get what they need and where to return them. Many interruptions will be avoided by using this method of set up.

MOTIVATION IS EVERYTHING

Getting children excited about their art project is a necessary prerequisite for all lessons. It is important for a student to enter into each project with enthusiasm. This requires motivation. (*If you are excited about the project this enthusiasm will transfer to the class.*)

TEACHER'S COMMITMENT

You must be committed to the project. Believe in the lesson and the children will sense your feeling that this a project that deserves their time and effort. How can you generate enthusiasm if your are not excited about the project?

CHILDREN'S INVOLVEMENT

Allow students to share their personal experiences with the subject matter presented. For example, if the project involves winter sports, let them describe what it looks like when someone is skiing. This should spur others to share their images on the subject. (*Let them piggyback their ideas to increase enthusiasm.*)

OUTSIDE STIMULUS

When appropriate, have films, music, slides or pictures about the technique or subject. These may precede the project or may be done while the project is being completed.

ART HISTORY

A brief presentation of works of art of well-known artists with a print example adds historical dimensions. If you motivate properly the children will sense your excitement and affection for the project and this will show in their work.

CLEAN UP

There is no maid service in public schools. Your art room will never be spotless but with a little effort on your part an inviting atmosphere can be created. Work to establish a sense of responsibility on the part of the students to keep a clean art room.

THE CUSTODIAN

An extremely important person to an art teacher is the custodian, since the art room is notoriously the messiest room in the school. If you remain on good terms with them you will have an important ally. Treating the custodian in a courteous and friendly manner and doing your part to keep the room clean may pay off in a cleaner room and fewer complaints to the principal.

STUDENTS

It is not pleasant for students to come into a room that is dirty or sit at a table that has not been cleaned. Each class should be held responsible for cleaning up its own mess. Get into the habit of dismissing the students by tables at the end of each class. Do not allow students to line up until they have returned all supplies that they have been working with. They must also have thrown away scraps from the table and floor.

If additional clean-up is needed, ask the classroom teacher if two or three student volunteers can stay after class for five minutes to do more work. Students are usually eager to do this. Cleaning is made much easier with most of the students out of the room.

VOLUNTEERS

An extra pair of adult hands to help clean the room will make clean-up time a breeze. After the students have done their part, the volunteers can go over table tops with a damp sponge, wipe off glue containers, clean the sink area or help set-up material for the next class (*see volunteer section*).

MATERIALS

Here are a few hints on materials that will help with your clean-up:

1) Large cans – ask the cafeteria employees to save large cans that fruits and vegetables come in. These make excellent water and wheat paste containers. The best part is that you are recycling the cans in your art room.

2) Egg cartons – another material you can recycle is egg cartons. Ask the students to bring them to school. Pour your tempera paint into the individual egg holders. You don't need to wash them, just toss them out.

3) Barrels – instead of having small overflowing wastepaper baskets in the room, ask for one large plastic barrel. This will eliminate the constant emptying of the smaller containers.

KEEPING THE CHILDREN CLEAN

Ask students to bring to school a smock or old large shirt to protect their clothing. Children in K-2 do not mind wearing smocks but after that they usually feel too sophisticated to put them on. Other ways to protect their clothing are rolling up sleeves and standing up to work.

DISCIPLINE: KEEPING SANITY IN YOUR CLASSROOM

Discipline is a necessity! Without it you are doomed to failure. Every class needs a certain amount of discipline; without it you and your class will not work up to your potential. You will lose the children's respect if you do not establish a firm yet friendly control.

NOISE LEVEL

Yes, talking should be permitted but kept at a low level. Most students object to an "anything goes" atmosphere and are not able to do their best work under these conditions.

SEATING CHART

Making up a seating chart may sound too structured for an art class. However, anyone with teaching experience knows that certain students should be separated in order for them to do their best work. An art teacher sees so many students during the course of a week that you'll need this chart to remember names.

REWARDS OR PUNISHMENT

Reward the class for good behavior instead of punishing for poor behavior. You will get better results. Giving detention after school, keeping students in from recess and other punishments are negative in nature and make for bad feelings between student and teacher.

THE REWARD SYSTEM

Initially, it takes a little work to set the reward system in motion but once it goes into effect you will find that the students respond to this structure and it was worth the work. I make up a chart like this for each grade level.

GRADE ONE								
Mr. Smith								
Ms. Brown								
Ms Woods								

When the students come into the room put 3 circles on the blackboard. If any one student or the whole class becomes too noisy, put a check mark into one circle. If the class or a student is noisy a second time, put a check in the second circle. If the class receives no checks or one or even two, the class gets a star on the grade level chart. If all 3 circles have a check mark, no star is given.

At the end of the first semester, give a party to the class at each grade level that has the most stars. Start the contest and chart over again for the second semester. Giving a good behavior party can be very simple. Each child should choose one item of food (*or cups, napkins, paper plates*) to share with the class. After eating, play a game – "Pictionary" is appropriate for an art class party.

GRADING

Specialists see a great number of students during the year. To give each child an accurate grade is nearly impossible. Yet, many art teachers are expected to do just that.

GRADES BASED ON EFFORT

Students should not be graded on artistic ability at the elementary level. Children should feel positive about their achievements in art and thus grading seems to be detrimental to the creative spirit that we wish to foster. If a grade is required, it should reflect effort only.

GRADES BASED ON ABILITY

However, there are many school systems that require art teachers to give grades based on ability. If you are in such a situation, let me give you some suggestions on what has been useful to me. You might be asked to give grades for as many as 500 students, so you need a simple approach that does not bog you down.

a) At the beginning of each year go to your school secretary and ask for a list of all students in the school. These student names should be grouped according to classes. Staple the class lists together and keep it in an easily accessible place.

b) Each time an art project is completed, walk around the room and note the projects that you think are the most creative. (*Of course this is highly subjective but in some school systems a grade is required.*) When the class leaves, pull out your class list and make a check beside these names. Do this after each project. Obviously some students will have many checks beside their names and others will have none.

c) Now, let's suppose that your grading system is A, B, C, D and F. Eliminate the D and F! To give any child in grades K-6 a D or F in art is ridiculous! Those students who have many checks beside their name will get an A, those with a few checks will get a B and the rest will get C's. Be generous with B's, save A's for anyone who shines and gives a sprinkling of C's to those who have done less than you expected.

START COLLECTING

There are many art projects that could be made more interesting with the help of some materials that are above and beyond the regular art supplies. Some special materials must be ordered through catalogs but many can be brought in from home by school children. Send a note home or put a message in the school newspaper asking for contributions.

Here is a sample letter that could be used:

Dear Parent,

The art classes will be able to make use of the following materials that you might find around your home. Please save them and have your child bring them to the art room.

1) *egg cartons*
2) *buttons*
3) *fabric scraps*
4) *cardboard cylinders from paper towels & toilet paper*
5) *styrofoam meat trays (<u>well</u> washed)*
6) *yarn*
7) *lunch bags*
8) *coffee cans*
9) *string*
10) *jar lids*

Thank you!

Sincerely,

ART EXHIBIT

June is approaching and the end of the year events are in full swing. These activities might include band, orchestra and choral concerts, a class play and the start of Little League Baseball. Each of these functions is important to the school but not everyone participates in them; most of the time children are spectators. There are very few times in any school year when each child becomes an active participant in an event.

An art exhibit is the exception! Every child in the school has something on exhibit. Each child is involved. This involvement will help to develop high self-esteem in all of the children. And, after all, isn't developing positive self-esteem a priority in a student's life at school? Each student will see that his art work is valued because it will be on display for all to see.

START EARLY

When do you begin planning for an art exhibit? You begin on the first day of school. An art exhibit should show the scope of your art program so you will want to begin saving projects from the very beginning.

KEEP RECORDS

Go to the school secretary and ask for a class list of all the students. Keep this list in a handy spot. Each time you take an art project that will eventually go in the exhibit, write the project saved next to the child's name. This record keeping is vital if you want to be sure that no student is left out of the exhibit.

PREPARE PROJECTS AS YOU GO

As soon as you select a project to go into the exhibit and have recorded it, glue it onto a larger piece of construction paper that will serve as a frame. Pre-cut 1" x 12" white strips of paper that will be used as identification on the project. On this strip print the child's first and last name and grade/teacher initial. For example:

John Doe 4W

This not only identifies the student by name but let's people (who do not know the child) see what grade he is in.

STORAGE

Saving projects for the art exhibit throughout the year is always a problem. Schools are famous for lack of space!

Here are some storage spots you might use:
 a) locker tops
 b) closets throughout the school that are not being totally used
 c) projects placed in large boxes, then stacked
 d) empty lockers

Don't forget to cover your projects with paper to keep them clean and prevent fading. Keep a record of where you store the projects.

COMMITTEE

Two months before the exhibit is to be held, form a committee from PTA members to help you. This is important as there are many details to be attended to. Here are some responsibilities to delegate:
 a) Contact the middle school music teacher. This teacher should select a small group of student musicians to play the evening of the exhibit. Attempt to get students who previously attended your school.
 b) Request parent volunteers to bring finger food, and set up a punch/ coffee table.
 c) Contact parents with "green thumbs" who might bring in freshly cut flowers to place on the food table and other locations around the room.

PRELIMINARY PREPARATIONS

1. Ask your principal to hire a substitute for one day prior to the exhibit and on the day of the exhibit.

2. With your principal, select a room where the exhibit could be held. The gym or cafeteria are both good spots. If the weather is nice perhaps the students could picnic outside or play an outdoor sport in physical education.

3. You'll need something besides the four room walls to display your work. Some teachers use portable blackboards in their classrooms. These

make excellent display panels.

4. To stick the projects on the walls or display panels, do not use masking tape. If the weather becomes humid, the projects will fall. Buy a gummy adhesive for hanging up things. (*There are several fine brands but I have used "EZ tac" with good results.*) These adhesives do not harm the walls or projects, keep their strength, and are re-usable.

SOME FINISHING TOUCHES

1. Name your exhibit! Using large poster board have your students design a title to be hung at the exhibit entrance

RIVERFIELD REMBRANDTS!

2. Arrange your exhibiting panels for easy viewing and good traffic pattern.

3. Ask for student volunteers (*from each grade level*) to sit at small tables during the exhibit. These children should choose a favorite project and work on it.

ADVERTISE

1. Have a student design a take home flyer that announces the exhibit and gives the date, time and place. Each child in the school should be given one or more to give to parents, grandparents, and neighbors.

2. Announce the exhibit in the school newspaper and PTA bulletin.

3. Write or phone your local newspaper. They may want to send a photographer the night of the exhibit to take pictures for a follow-up story.

4. Send invitations to:
 a) Mayor and other town officials
 b) Superintendent of Schools
 c) Board of Education Members

CLEAN UP

1. Arrange your schedule so that you have a 5th or 6th grade class for your first class the day after the exhibit. They will be in charge of taking down and returning the projects. Since each project has the name of the student and class on it, this will not be a difficult job. Make room signs for each class and tape them to the wall. As a project is taken down, it should be placed in a pile under the correct sign.

2. When everything has been taken down, have students from your first class return the projects to the classrooms.

3. Pick up any paper scraps and try to get the room back in shape! This is essential if you want permission to use the room the following year.

THANK YOU NOTES

Thank you notes are an important courtesy. These people deserve special hand -written notes to let them know how much you appreciate their efforts:

1. PTA Committee
2. Music Teacher
3. Musicians
4. Custodian
5. Other special people who may have attended the Art Exhibit.

CLAY

Working with clay is an exciting time for children. When you announce a clay project you will see an eagerness to get started. Enter into the excitement but know what you are doing. The following information will help you through the clay process

CERAMIC TERMS

Bisque – fired clay that has not been glazed.

Bone Dry – dry, ready to be fired.

Cone – a small three-sided piece of clay that bends at a specific temperature.

Firing – baking the clay.

Glaze – a material used to make clay glassy.

Greenware – unfired clay.

Kiln – oven for firing clay. A kiln with a "sitter" is easy to operate

Kiln wash – a liquid that is brushed on kiln shelves to prevent glaze from sticking.

Stilt – a three pronged clay support.

Wedging – cutting then pounding clay to get out air bubbles.

SUPPLIES YOU WILL NEED

1. **Clay** – moist clay that requires an 06 cone for firing (usually sold in 50 lb. plastic containers) 2-3 lbs. per student.

2. **Kiln** – as large as your budget will allow, with kiln sitter which shuts off `the kiln when a cone reaches the required temperature.

3. **Hood Exhaust** – a vented exhaust fan that is installed directly above the kiln to remove toxic fumes.

4. **Shelves for kiln** (4 or 5).

5. **Shelf support** – for stacking one shelf on top of another.

6. **Stilts** – (50-75).

7. **Kiln wash** – approximately 1 quart.

8. **Cones** – fired to 06 (bisque firing)
 Cones – fired to 05 (glaze firing)

9. **Glazes** – liquid form with no lead content
 (6-10 colors) 2 pints of each color.

10. **Brushes** – stiff bristle for applying glaze.

11. **Gloves** – heat resistant.

12. **Clay cutter** – a thin 18" wire fastened to two small pieces of wood.

13. **Plastic screens** – to line room shelves where clay will dry.

14. **Plastic garbage can with lid** – for clay storage.

15. **Plastic wraps and plastic bags**

16. **Wood clay tools** (pencil shaped)
 1 per student

TIPS FOR GOOD RESULTS

At the elementary level, choose simple projects ideas that do not have thin parts. Students have more success in making a short legged pig than a horse which has long skinny legs. (You will find clay projects included in each set of class lessons.)

If the object students are working on has several parts, (an animal for example) show them how to pull out the legs, etc. from the clay rather than attaching two separate pieces. By using this method the clay parts will not fall off as easily.

When it becomes necessary to attach two separate piece, scratch the surface of each where they are to be joined, add a few drops of water and press the pieces together.

Students may want to add details such as eyes, nose, mouth and hair when they are finished. This may be done by scratching the clay using wooden clay tools.

As the students are working, they may find the clay starting to dry out. When this happens, sprinkle a few drops of water on the clay. They should then work the water into the clay.

A clay piece that is too thick (more than 1/2" thick), should be hollowed out with a spoon. This will allow the clay to dry quicker and there will be less chance of it exploding in the kiln.

A clay project that cannot be finished in one sitting should be wrapped with a damp cloth and covered with plastic to prevent drying out. However, at the elementary level, students are usually able to complete a project during one class period.

Finally, scratch the students' initials on the bottom of the clay. If room permits you may also scratch the date.

Save the clay scraps as they can be wedged and used again. Store dampened clay in plastic bags that are placed inside a garbage can.

Place the clay pieces on shelves that have been covered with the screening. The screens allow air to pass under the clay and help prevent warping as the clay dries. Cover the clay with a sheet of plastic wrap. By doing this you slow down the drying time, which prevents cracking of the clay. The plastic wrap should remain on the clay for one week, then remove it and air dry the clay for an additional 2 weeks or until subject is bone dry.

BISQUE FIRING

When firing the clay for the first time, you do not need to place each clay piece on a stilt. The pieces may touch each other and may be stacked one on top of another. Put the 06 cone in the kiln sitter (*this is an automatic device that shuts off the kiln*). Leave the kiln lid open for the first hour with the temperature setting at low. After the first hour move the setting to medium and then set the next hour at high. The firing time is about 6 hours. Even with a "kiln sitter to shut off the kiln, do not leave the school until you unplug the kiln. Do not open the kiln for 24 hours.

GLAZE FIRING

Have students select color of the glaze that they want. Use a brush to coat the clay with one layer of glaze, do not glaze the bottom. Let the glaze dry for a couple of minutes then apply a second layer of glaze. Never glaze the bottom.

Place each clay piece into the kiln on stilts. Do not allow the clay pieces to touch each other or they will fuse together during firing.

For glazing put the 05 cone in the kiln setter. Leaving the kiln lid open for 1/2 hour, set the temperature at medium. After you close the lid go directly to the highest temperature setting. The firing time is about 5 hours. (*Remember to unplug the kiln before leaving the school.*) Again do not open the kiln for 24 hours.

SPECIAL EDUCATION CLASSES

PUDDING MONO PRINT

As you overcome your initial reluctance to attempt this project you will discover an art project that young people love.

WHAT IS NEEDED
1. Instant chocolate pudding (one package for 6 people)
2. Bowl for mixing (one bowl per class)
3. Large spoon
4. Water
5. Tin foil – tear off 20" strips
6. 12" x 18" white construction paper

WHAT TO DO
1. Mix pudding according to package directions.
2. Place tinfoil on table in front of child.
3. Spoon or pour approximately 1/3 cup pudding onto tin foil.
4. Smooth pudding to cover tin foil.
5. Make patterns or pictures in the pudding using your fingers.
6. Place white paper on top of pudding and press gently.
7. Lift paper. Allow drying time. You now have a mono-print!

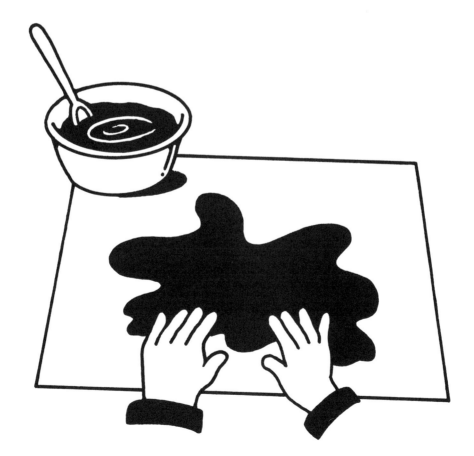

SPONGE PRINT

An array of mixed colors will result in simple understanding of mixing colors in this sponge print project.

WHAT IS NEEDED

1. 3" x 4" sponge (one per child)
2. Food Coloring (yellow, red, blue)
3. 12" x 18" white construction paper
4. Water
5. Three bowls
6. Three spoons

WHAT TO DO

1. Pour food coloring into 3 bowls, one bowl for each color.
2. Stir in water (not too much water or you will dilute the color too much).
3. Place one end of sponge into food coloring (if you dip the sponge in too far you will get too much liquid in the sponge and it will drip).
4. Dab sponge onto paper.
5. Using the same sponge to allow colors to mix, change colors frequently.

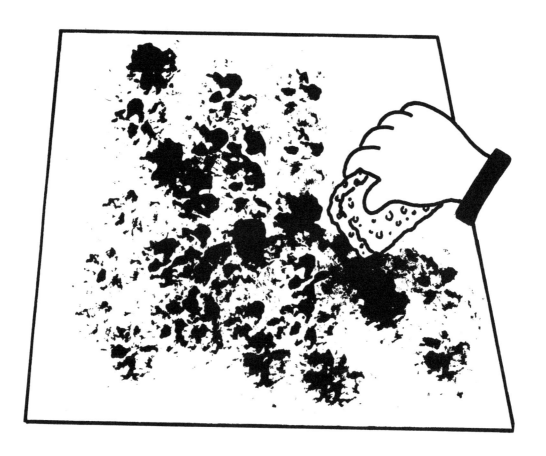

SUGAR PAINTING

This project couples two interests of children, their love of abstract forms and creative use of color.

WHAT IS NEEDED

1. White glue
2. Colored sugar (one cup per class)
3. 12" x 12" black construction paper
4. Sugar dispenser (a jar with holes in lid). Two children could share one.
5. Newspaper

WHAT TO DO

1. Fill dispenser with sugar.
2. Pour glue onto paper in design or picture desired.
3. Shake small amount of sugar on top of glue.
4. Turn paper upside down and tap above newspaper to remove excess sugar.
5. Dry separately for one day.

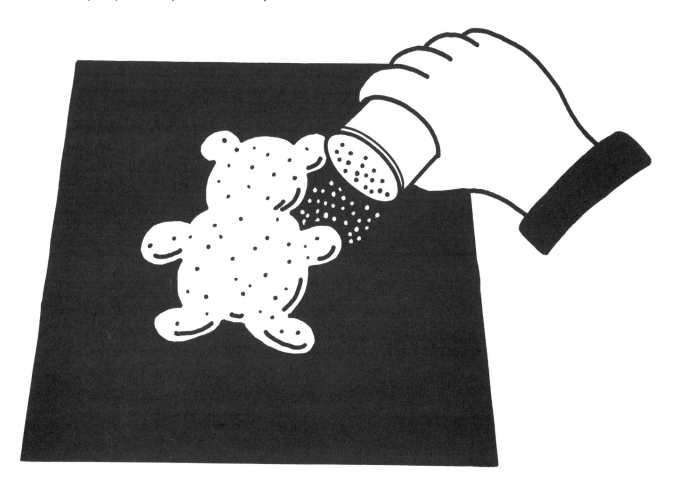

COLLAGE

An assemblage of odds and ends can make an interesting collage.

WHAT IS NEEDED
1. 12" x 12" construction paper (any color)
2. Newspapers
3. Construction paper scraps
4. Tissue paper
5. Yarn
6. Wallpaper books
7. Glue
8. Scissors

WHAT TO DO
1. Tear or cut the newspapers, construction paper scraps, tissue paper and wallpaper into any shape and size.
2. Glue on pieces of yarn (pre-cut by teacher, approximately 6" in length) and the paper that had been cut or torn. Overlap.

CHEERIO COLLAGE

This collage is fun and easy for both the teacher and the student. A few Cheerios gobbled up will not hurt the art work.

WHAT IS NEEDED

1. Box of Cheerios
2. White glue
3. 6" x 9" poster board (red, blue, green or violet)

WHAT TO DO

1. Dab multiple small glue dots on poster board to form a design or picture. Do no more than 6 to 8 dots at a time or the glue will dry.
2. Place Cheerios on top of glue.

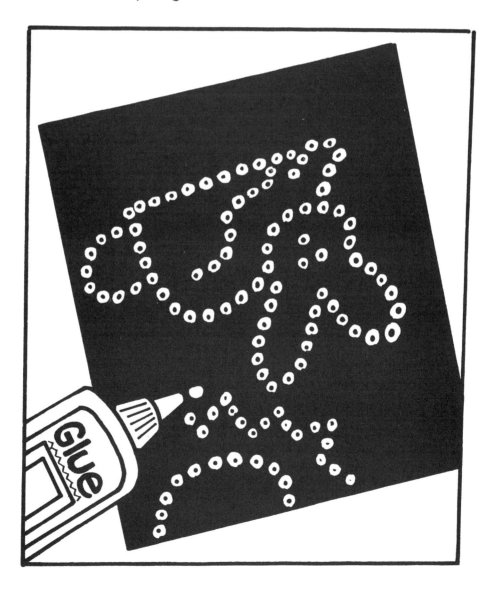

PAINT WITH WATER

Learn what it feels like to paint by using water on the blackboard.

WHAT IS NEEDED
1. Bucket of water
2. Brush
3. Blackboard

WHAT TO DO
1. Fill bucket half full of water.
2. Stand at blackboard with bucket beside you.
3. Paint with water onto blackboard.

FLOOR MURAL

Feel the freedom of working on the floor!

WHAT IS NEEDED
1. Mural paper
2. Masking tape
3. Large crayons

WHAT TO DO
1. Roll mural paper out on floor. Tape ends to floor to prevent paper from rolling up.
2. Remove shoes.
3. Sit or lie on paper.
4. Give each child a box of crayons.
5. Draw (or scribble).

WOOD SCULPTURE

Block building is a part of every child's world. In this project we build a construction that will last.

WHAT IS NEEDED
1. Wood scraps – various sizes (not rough)
2. Glue
3. Brushes
4. Tempera

WHAT TO DO
1. Give children time to play with the blocks.
2. Glue wood pieces together to make real (train, building, etc.) or abstract sculpture.
3. Allow glue to dry.
4. Paint.

STRAW PAINTING

Kids love to blow through straws and with this simple project, young children can create exciting explosions of color.

WHAT IS NEEDED
1. Drinking straw
2. Food Coloring (yellow, red and blue)
3. 12" x 12" white construction paper

WHAT TO DO
1. Pour approximately one tablespoon of each color of food coloring onto paper. (Leave a few inches between each color.)
2. Place a straw at edge of food coloring at a 45 degree angle and blow.
3. Allow paint to flow at random. Some of the paint should run into each other, blend and form new colors.

SHAVING CREAM FINGER PAINT

Your students will love the feel of this.

WHAT IS NEEDED

1. Shaving cream (3 cans per class)
2. Tables (formica tops are best)
3. Tempera

WHAT TO DO

1. Spray generous amounts of shaving cream on the table.
2. Sprinkle a few drops of tempera on the shaving cream to add color.
3. Use your hands to mix and move around shaving cream to create a picture.

CLAY PAPER WEIGHT

Get the feel of clay with this no-fail project.

WHAT IS NEEDED

1. Water-based clay (size of tennis ball)
2. Glaze – several colors
3. Felt (pre-glued peel-off circles)
4. White glue

WHAT TO DO

1. Child should mold a smooth clay form that is flat on one side. Keep clay in one piece.
2. Scratch name of child on flat side.
3. Allow clay to dry three weeks.
4. Fire clay then glaze clay (see clay section, page 23).
5. Glue felt to flat bottom.

KINDERGARTEN
&
GRADE ONE

ZOO CAGE

Who doesn't love to go to the zoo! March these cages around your room or hall.

WHAT IS NEEDED

1. Four 1" x 18" black construction paper strips
2. Two 6" x 6" black construction paper squares
3. 18" x 24" manila construction paper
4. Tempera paints
5. Brushes
6. Water containers
7. White glue

WHAT TO DO

1. Discuss various zoo animals and how they look.
2. Select one animal and make a large painting of it on the manila paper.
3. Allow paint to dry (10-15 minutes).
4. Glue on four cage bars.
5. Round off corners of two black construction paper squares to make wheels and glue wheels at bottom.

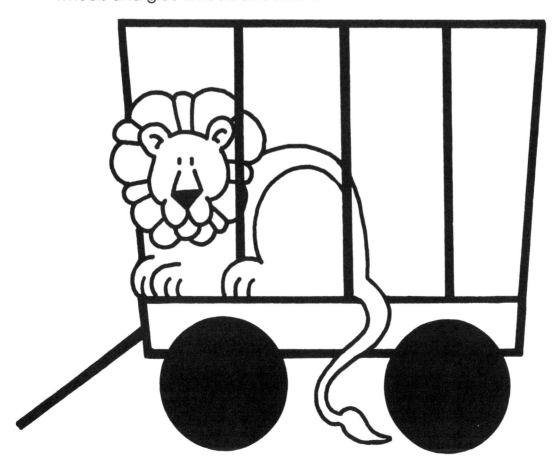

CHALK FLOWERS

Soft pastel colors give a special feeling to this floral project

WHAT IS NEEDED
1. 18" x 24" white construction paper
2. Black Markers (wide tip)
3. Colored chalk (pastel colors)

WHAT TO DO
1. Draw 2 or 3 large flowers, stems and leaves with markers. Flower stems should be double so that there is an area to color.
2. Use chalk to color in the flowers.

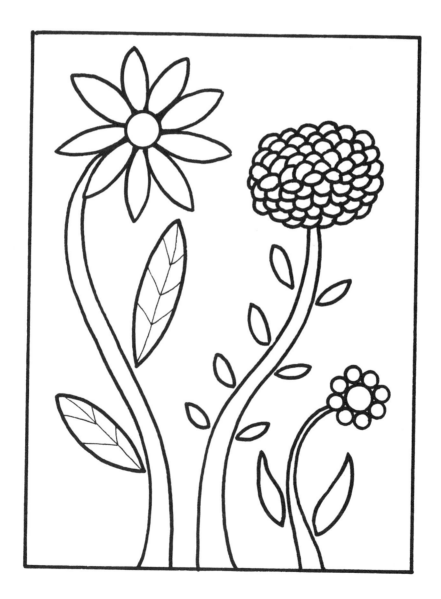

NATURE COLLAGE

This nature collage allows young people to express their love of collecting and the art of selecting.

WHAT IS NEEDED
1. 6" x 9" cardboard
2. White glue
3. Small paper bag

WHAT TO DO
1. You're going outside so choose a pleasant fall or spring day.
2. Walk around the schoolground and collect interesting pebbles, weeds, sticks and leaves and put them in your paper bag.
3. Go back to the classroom with your "treasures" and glue them onto you cardboard in an interesting arrangement.

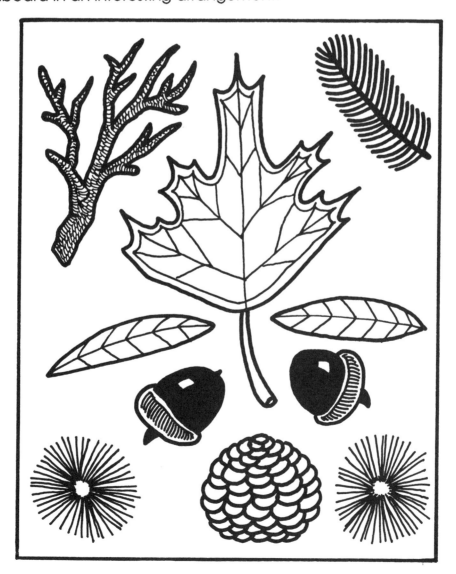

FINGER PAINTING/BOATS

Finger Painting is fun but the results are not often aesthically pleasing. Try this mixed media as a new twist for better results.

WHAT IS NEEDED
1. Blue, white and green finger paints
2. 18" x 24" finger painting paper
3. Spoon
4. Scissors
5. 9" x 12" white construction paper
6. 9" x 12" black construction paper
7. White glue
8. Paper cutter (for teachers use only)

WHAT TO DO
1. Spoon out approximately two tablespoons of blue paint, two tablespoons of white paint and one tablespoon of green paint onto the finger painting paper.
2. Mix the colors with your hands, be sure that you cover the entire paper with color.
3. Using your fingers and hand, make ocean waves.
4. Dry projects for one day.
5. Trim off curled-up edges by using the paper cutter.
6. Cut sails from white paper and make the masts and boat hulls from black paper (students may draw forms before cutting). Make two or three sailboats of different sizes.

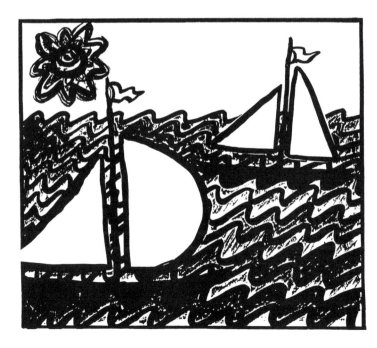

ABSTRACT PAINTING

New color discoveries and experimenting with shapes are generated in this art project.

WHAT IS NEEDED

1. Tempera paint (yellow, blue and red)
2. Brushes 1/4"
3. Water container
4. Egg containers
5. 9" x 12" white construction paper (2 per student)

WHAT TO DO

1. Demonstrate how secondary (orange, violet, green) colors are made by mixing two primary colors (red, yellow, blue) together.
2. Let them experiment by mixing paints on their paper.
3. When they have finished, let them show each other the colors they have made.
4. Now give them a second paper. This time they will mix colors again and also see what interesting shapes they can create.

STABILE

A colorful 3-D creation is the result of this simple project.

WHAT IS NEEDED
1. 1" x 18" construction paper strips – all colors (10-15 per student)
2. 6" x 9" poster board – different colors (one per student)
3. White glue
4. Scissors

WHAT TO DO
1. Fold each strip in the following manner:

Each fold is about 1" from the end.

2. Strips may be cut into varying lengths.
3. Put glue on the ends that were folded up.
4. Glue to poster board.
5. Overlap and glue one on top of the other as illustrated.

"ME" PAINTING

A young child's world is very small, the center of it is the child himself. Make use of this by painting a self-portrait.

WHAT IS NEEDED
1. Two 18" x 24" manila papers
2. Tempera paint
3. Brushes 1/2"
4. Water containers

WHAT TO DO
1. Discuss body proportion with the class. Have a student come to the front of the class. Point out that the head is smaller than the body, the legs and arms are long, etc.
2. Remind students that this is a self-portrait. They need to remember what length their hair is, what they are wearing, etc.
3. After their first painting is finished, help students evaluate what they have done. For example, you might help them to see that the hair is the wrong color or the head is too large for the body.
4. Give students a second paper and have them repeat the project, this time they are to make the necessary corrections.

BODY TRANSFORMER

Who can deny the allure of this body transforming project!

WHAT IS NEEDED
1. Mural paper 36" wide
2. Pencils
3. Markers
4. Crayons
5. Scissors

WHAT TO DO
1. You're going to need a lot of room – go out into the hall.
2. Roll out long sheets of mural paper and tape edges to prevent rolling up.
3. Have students lie down on paper in any position but do not overlap arms and legs onto body.
4. Teacher and parent volunteers trace around each child with pencil. Pencil must be held in a vertical position to prevent distortion.
5. Students then take markers and crayons (use crayons for large coloring areas – markers run out of ink) and transform the outline into any character – monster, superman etc.

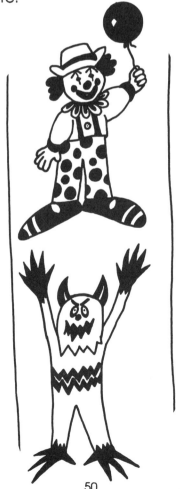

CLOWN

Make a clown, make a clown, make a clown and watch their imagination take off!

WHAT IS NEEDED
1. 9" x 12" construction paper (an assortment of colors) (two per student)
2. 6" x 9" construction paper (an assortment of colors) (one per student)
3. Construction paper scraps
4. Glue
5. Scissors

WHAT TO DO
1. Fold one 9" x 12" paper "accordion style." This is the clown's body.

2. Cut the second 9" x 12" paper to make the arms and legs.

3. The 6" x 9" paper should be cut in a head shape.
4. Glue the arms, legs and head to the body.
5. Cut and glue on feet, hands, hat, buttons, etc. from the scrap paper.

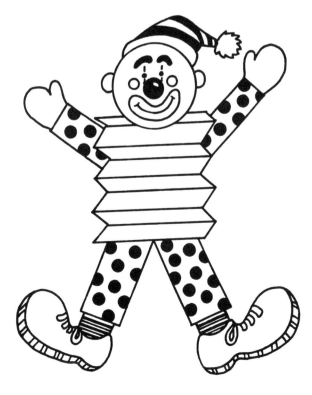

TAMBOURINES

Where's the band? When you finish with these tambourines – have a parade!

WHAT IS NEEDED

1. Two paper plates (white)
2. Tissue paper – bright colors (10 sheets per class)
3. Tempera paint
4. Brushes – 1/4"
5. Water containers
6. A dozen pebbles (approximately the size of a pea)
7. Scissors

WHAT TO DO

1. Paint bold designs on the bottom of each plate.
2. Cut tissue paper into strips (approximately 1" x 9"). Each child should cut 12 strips.
3. Glue one end of tissue paper to the inside of one plate as follows:

4. Place pebbles on plate – this will make the noise.
5. Glue the two plates together so that the painted part of the plate is exposed and the pebbles are trapped between the plates.

CLAY PINCH POT

Working with clay "pinch pots" in kindergarten and first grade is a good introduction to clay which will lead to more advanced work later.

WHAT IS NEEDED

1. Water-based clay (baseball size)
2. Glaze
3. Brushes - 1/2 "

WHAT TO DO

1. Give each student a ball of clay.
2. Use both thumbs to make a hole in the ball.
3. Pinch the sides (between the hole and outer edge of ball) to form bowl or "pinch pot."
4. Care should be taken not to make any part of the clay too thin.
5. See section on clay for firing and glazing.

SELF-PORTRAIT – HEAD

Notice the change from start to finish in this self-portrait lesson.

WHAT IS NEEDED
1. 12" x 18" manila paper
2. 12" x 18" white construction paper
3. Pencil
4. Markers

WHAT TO DO
1. Before you begin discussing how to draw the face, remember not to get too technical at this young age. However, you can point out a few beginning basics:
 a) The head shape is an egg shape, not a circle.
 b) Place the eyes just above the middle of the face, most students place them too high.
 c) As you draw, remember that every face is different.
2. Give them a pencil and 12" x 18" manila paper. Have them draw a practice face. When finished discuss it with them.
3. Finally with makers and 12" x 18" white construction paper have the students draw a self-portrait. Remind them to draw their own individual characteristics (hair and eye color for example).

VEGETABLE – FRUIT PRINT

It's so much fun to print with these natural designs from the kitchen and the results are great!

WHAT IS NEEDED

1. A variety of fruits and vegetables (each child brings one to school and they share) such as, apple, potato, carrot, and onion (if you can stand the smell)
2. Knife (a paring knife for the teacher)
3. 12" x 18" white or pastel construction paper
4. Tempera paint – all colors
5. Brush - 1/2"
6. Egg cartons
7. Water containers

WHAT TO DO

1. The teacher or volunteer cuts each fruit and vegetable in half.
2. Demonstrate:
 a) Brush a small amount of paint onto the cut area.
 b) Stamp the fruit or vegetable gently onto the paper – place squarely on the paper, do not move from side to side, carefully lift up.
 c) Overlap.
 d) Stamp 2 or 3 times before brushing on more paint, a speckled look is fine.

STRING RUBBING

Looping and curving string creates a pleasing harmony of lines.

WHAT IS NEEDED

1. 12" x 18" unprinted news
2. Crayons – dark colors (used broken crayons with the paper removed)
3. 1' long string

WHAT TO DO

1. Place string in any position under the unprinted news.
2. Choose two or three colors of crayons that you think look good together.
3. Using the side of the crayon only rub the crayon on the paper above the string. Press down hard with the crayon and try not to move the paper.
4. Place the string in a new position and repeat the process until the paper is filled to your satisfaction.

FALL TREES

The bright colors of an autumn tree are captured in this mixed media picture.

WHAT IS NEEDED

1. 18" x 24" manila paper or 18" x 24" light blue construction paper
2. Crayons
3. Red and yellow finger paints
4. Two paper plates
5. Two spoons

WHAT TO DO

1. Go outside and take a good look at trees, especially the trunk and branches. Notice how the trunk is the fattest part of the tree and that branches are different sizes. If the leaves have turned to fall colors, see how many colors you can find.
2. Return to the classroom. Hold your paper vertically and draw one large tree that fills the space. Use you black and brown crayon to do this.
3. Spoon yellow finger paint on one paper plate and red on the second plate.
4. Put your hand in the paint. Now use your hands to make the leaves on your tree. Avoid making a circle shape for your tree.
5. Wash your hands!
6. With your crayons, add things to your picture that will make it interesting (people, birds, etc.).

SNOW SCENE

Dramatic results come to this cold winter scene when students use their imaginations.

WHAT IS NEEDED
1. 18" x 24" blue construction paper
2. Black crayon
3. White tempera paint
4. Egg carton
5. Brush – 1/2"

WHAT TO DO
1. With your black crayon, draw an outdoor winter scene but do not put in any snow. Here are some suggestions:
 a) people doing winter sports
 b) trees, mountains, ponds
 c) building – city or country
2. Now add the snow with your white paint. Here are some suggestions:
 a) snow on tree branches
 b) falling snow
 c) snowmen
 d) snow on rooftops
 e) banks of snow

WEAVING

An introduction to weaving is achieved on this paper loom.

WHAT IS NEEDED
1. 12" x 18" construction paper (all colors)
2. 1" x 18" construction paper strips (six to eight per student)
3. Scissors
4. Pencil

WHAT TO DO
1. Fold the paper in half lengthwise.

2. Draw three lines approximately 1" from the papers edge (start and end on the folded side).

3. Draw six to ten lines starting on the fold and ending at the opposite line. (The lines may curve or zigzag a little.)

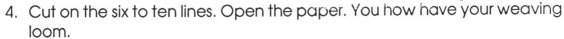

4. Cut on the six to ten lines. Open the paper. You how have your weaving loom.
5. Take the paper strips and weave over and under. Weave the strips until you fill the opening in alternating rows (one row will be over-under, the next row will be under-over etc.).

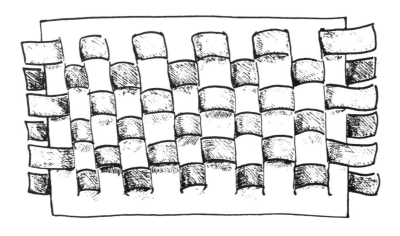

CREATIVE CONCOCTION

You're going to love this one! Their imagination will run wild!

WHAT IS NEEDED

1. Paper plate
2. Drinking straws – two per student
3. Pipe cleaners – approximately three per student
4. Styrofoam – the peanut shaped ones used in packing – approximately three per student
5. Oil-base clay, the size of a ping-pong ball
6. Scissors

WHAT TO DO

1. The paper plate serves as the base of this sculpture.
2. The clay is used as "glue" to attach the straws and pipe cleaners to the plate.
3. Cut straws in 1/3's.
4. Place pipe cleaners inside straws and push one end into the clay (bubble gum size).
5. Pipe cleaners can be punched into styrofoam.
6. Bend the pipe cleaner the way you want it to look and place the end in a straw and both into another wad of clay. (The illustration will help to guide you.)

SQUARE/TRIANGLE DESIGN

Here is a simple way to create an eye-catching geometric design.

WHAT IS NEEDED

1. Pre-cut 1" squares of construction paper – black (You'll need a lot – as many as 20-50 per student)
2. 12" x 12" construction paper – white
3. Scissors
4. White glue

WHAT TO DO

1. Some of the squares will be left intact as squares. Some squares will be cut on the diagonal to form triangles.
2. Arrange the squares and triangles on the white paper. Try several designs. Do not glue until the design satisfies.
3. When you are ready – pick up one shape at a time and glue to the paper without destroying your idea.
4. It takes only a small drop of glue for each shape.

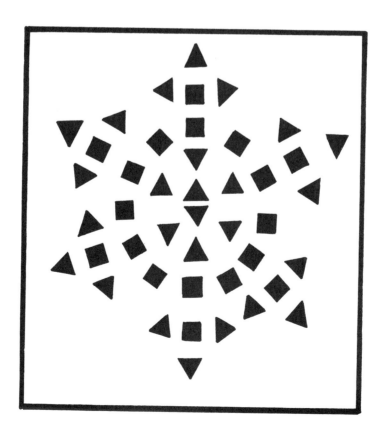

TORN PAPER ANIMAL

How can a project as simple as this be so creative!

WHAT IS NEEDED
1. 12" x 18" construction paper – white
2. 6" x 9" construction paper – any color
3. White glue
4. Colored markers

WHAT TO DO
1. At first, don't tell the students what they are making. Have them tear the 6" x 9" paper into any abstract shape. (They should end up with a fairly large shape.) Leave no straight edge on any side.
2. Have them turn the shape in all directions and ask them to find a real or pretend animal in the shape.
3. Now glue the shape to the white paper.
4 Take markers and add whatever details or parts are needed to make the animal complete.
5. Think of a setting for your animal and draw it with your markers.

PUPPET HEAD

A hand in this puppet will make it come to life.

WHAT IS NEEDED
1. Two paper plates
2. Construction paper scraps
3. Stapler
4. White glue

WHAT TO DO
1. Staple two plates together with the inside facing each other to form a pocket. Leave a space for the hand to enter.

2. Use construction paper scraps to add ears, eyes, whiskers, mouth, horns, antlers, nose, spots, etc.

CLAY – DINOSAURS

Dinosaurs will roam the earth again with this clay project.

WHAT IS NEEDED
1. Water-base clay – baseball size
2. Glaze
3. Brushes – 1/2"
4. Wooden clay tools – pencil shaped

WHAT TO DO
1. Check out dinosaur picture books from the library.
2. Show dinosaur pictures to class.
3. Form a dinosaur with the clay. Attempt to keep the clay in one piece as you pull out the legs, neck and head from the body.
4. Use clay took or pencil to make eyes and mouth.
5. See section on clay for firing and glazing.

Grade Two
&
Grade Three

ABSTRACT RADIATING FLOWERS

A fool-proof winner at any level, these radiating flowers will fill the paper with lively color.

WHAT IS NEEDED
1. 6" x 18" pastel construction paper
2. Markers

WHAT TO DO
1. Select three or four colored markers that look good with the paper color you have.
2. Take one of the markers and place 9 dots on the paper. Space the dots at random with some dots close together and some apart.

3. Take one of the markers you have chosen and make lines coming from a dot.
4. Around this shape, make a second (new color) row of lines. Lines should always go towards the center. Each ring of lines is the same length but different rings may vary in length.
5. As soon as the first dot's lines hit another dot, begin the same process on the second dot until it hits a new dot and so on.

WARM/COOL

Not luke warm, but hot! hot! hot! And cool man cool!

WHAT IS NEEDED
1. 12" x 18" construction paper – white
2. Colored felt pens – wide tip

WHAT TO DO
1. Fold paper in half.

2. Draw the same picture (almost any subject matter will do) on both sides in black marker.
3. On one half of the paper use markers to color everything a cool color (blue, green and blue violet).
4. On the other half of the paper use markers to color everything a warm color (yellow, red, orange and red violet).

CITY SKYLINE

This is a sophisticated looking project for second and third grade children but they can make this nighttime skyline easily.

WHAT IS NEEDED

1. Two 12" x 18" construction paper – black
2. Two 12" x 18" Construction paper – blue
3. 6" x 6" construction paper – yellow
4. Glue
5. White chalk
6. Scissors
7. Masking tape

WHAT TO DO

1. Tape the two blue papers together end to end horizontally. This is the back of your picture.

2. Place one black paper on top of another and tape together at the top and bottom to prevent paper from sliding.

3. On the top black paper, draw a city skyline. Vary the building sizes and shapes. Draw with one continuous line from one edge of the paper to the other. Do not go off the top or bottom.

4. While paper is still taped, cut out the buildings on the one you have just drawn.
5. Untape the two black papers.
6. Glue the two sets of buildings end to end on top of the tow blue papers.
7. Cut windows and a moon and stars (small dots from the yellow paper and glue.

SNOWFLAKE DESIGN

An unusual snowflake design will emerge when these snowflakes have settled.

WHAT IS NEEDED
1. Sixteen 4 1/2" x 6" origami paper
2. 18" x 24" construction paper
3. Scissors
4. Glue

WHAT TO DO

1. Select 4 colors with a total of 16 origami papers.
2. Fold each of the 16 papers in quarters.
3. While the papers are folded, cut out shapes 2 or 3 times on each of the four sides. Cuts may be curved, jagged or a combination of the two.
4. Unfold the 16 cut papers and lay them out vertically on the large construction paper (4 papers across and 4 down). Line the paper "snowflakes" with the edges of the large paper and each other – they'll just fit.
5. Glue them down to the large background.

STUFFED SHOE OR BOOT

These shoes are not made for walking they are just made for looking and they will look good hanging from the ceiling.

THAT IS NEEDED

1. Two 18" x 24" manila paper
2. String
3. Stapler
4. Scissors
5. Markers – wide tip
6. Crayons and pencil
7. Newspaper
8. Paper punch

WHAT TO DO

1. Draw a large shoe or boot on one sheet of manila paper. If your shoe or boot is tall, hold your paper vertically, if it is long, hold your paper horizontally. Be sure that it fills the space.

2. Place the two manila papers on top of each other. Staple them together with two or three staples (not on shoe) to prevent slipping.
3. While papers are stapled together, cut them out. You now have two identical shoes.
4. Lay the shoe drawing one on top of the other. Color both sides of shoe (stitching, words, eyelets) then use crayon for large areas of color.
5. Place the shoes on top of each other and staple three sides.
6. Crumple up newspaper and stuff into shoe on open side. Be careful not to put too much paper in or you will tear the shoes.
7. Staple the open end shut.
8. Use a paper punch to put a hole in the top middle of the shoe.
9. Put a string through the hole for hanging.

ROCK ANIMAL

The pet rock had entered your classroom. Make it come alive with this lesson.

WHAT IS NEEDED
1. A smooth rock about the size of a baseball – any shape
2. Acrylic paint
3. Brushes
4. Cans – for water
5. Felt
6. Wiggley eyes bought by teacher at craft store
7. Glue
8. Scissors
9. Fake fur
10. Pipe cleaners

WHAT TO DO
1. Give students a week's notice to select a rock with an interesting shape. Clean the rock thoroughly.
2. As you look at the rock try to find an animal shape. It may be real or imaginary.
3. Paint the rock. It may be a solid color, spots, stripes or anything else. (Do not paint eyes.)
4. Cut out felt or fake fur for ears, tail, wings, horns, legs, feet, whiskers, etc. and glue them onto the rock.
5. Glue on wiggley eyes.

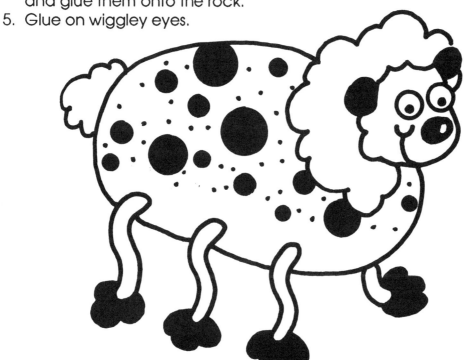

TEXTURE COLLAGE

Anywhere you can find texture it spells RELIEF with this rubbing project.

WHAT IS NEEDED
1. 12" x 18" white paper
2. Used crayons
3. Black markers

WHAT TO DO
1. Draw any idea (animal, boat, house for example) on your paper with a black marker. Draw the outlines only and keep large open areas between the lines.
2. Discuss what texture is (the surface of an object – rough, smooth). Look for textures around the classroom and hallways. Demonstrate by laying paper on top of a texture and rubbing with the side of a crayon.
3. Take picture and 2 or 3 used crayons that have the paper peeled off to a texture such as a brick wall. Place that part of the picture you want to be colored on top of the surface and rub with the side of your crayon.
4. Find a new texture and go through the same process on a new part of your picture.

POINTILLISM

Seurat's Pointillism will be "fingered" in this project.

WHAT IS NEEDED
1. 9" x 12" white construction paper
2. Watercolor set
3. Can (for water)
4. Pencil
5. Black felt pen

WHAT TO DO
1. Put a drop of water on top of each of the colors in a watercolor set. This softens the paint. While this is softening, show pictures done in Pointillism style.
2. With a pencil, draw a large simple picture on the white paper. A colorful picture is effective such as a parrot or butterfly.
3. Dab the forefinger only in one of the paint colors. Fill in an area of your picture by dabbing up and down with your finger that has paint on it.
4. Fill the whole paper in this manner. It is best not to mix colors in any one area too much or the picture will become confusing.
5. Outline shapes with pen for more definition (optional).

ROBOT

Design your own high tech companion of the near future.

WHAT IS NEEDED
1. 18" strip of tinfoil
2. 12" x 18" black construction paper
3. 6" x 6" red construction paper
4. 6" x 6" white construction paper
5. Glue
6. Scissors

WHAT TO DO
1. Discuss what a robot could be like. What parts could make up the robot, for example:

 dials, lights, antenna, speakers, springs,
 wheels, buttons and levers
2. Cut out the metal body, head, arms, legs from the tinfoil.
3. Use the red and white paper for details.
4. Glue the robot to the black paper.

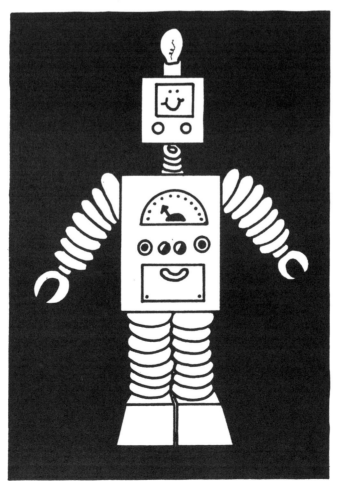

MOSAIC

Take this "seedy" material and glorify an art project.

WHAT IS NEEDED
1. 9" x 12" poster board
2. Glue
3. Bird seed, dried vegetables (beans, peas)
4. Yarn
5. Pencil

WHAT TO DO
1. Draw a large, simple idea (balloon, one flower, heart, etc.) on the poster board.
2. Glue yarn on top of the drawing outline. (Outline with glue first, then lay the yarn on top of the glue.)
3. Pour glue in an area (if you glue an area that is two large, the glue will start to dry) and spread it around so that the glue covers the section you are working on.
4. Sprinkle seeds or dried vegetables on top of the glue. A different kind of seed should be used for each object in your picture.

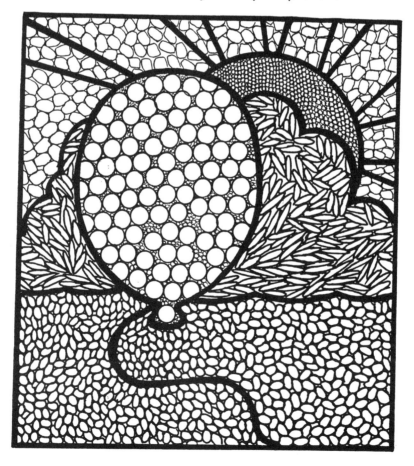

CLAY WHALE

Here is a whale of a project!

WHAT IS NEEDED
1. Water-based clay (baseball size)
2. Glaze
3. Brushes

WHAT TO DO
1. Show the class pictures that you have obtained from the library of different kinds of whales.
2. Demonstrate how the following can add character to the whale:
 a) Open mouth
 b) Slight twist of body
 c) Upturned tail
3. Try to keep the clay in one piece – pull out flippers and tail.
4. See section on clay.

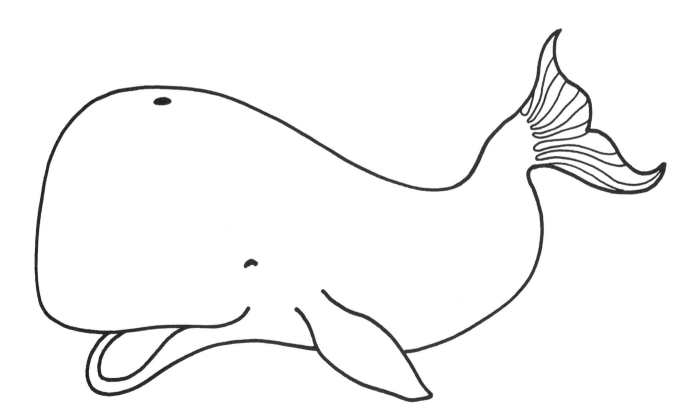

OVERLAPPING OBJECTS

"Build up" your students' skills by developing a sense of depth in this overlapping project.

WHAT IS NEEDED
1. 12" x 12" white construction paper
2. Colored markers
3. Pencil and eraser
4. Objects to be traced (ruler, scissors, glue bottle, etc.)

WHAT TO DO
1. Place on each table objects that can be traced.
2. Take one object, lay it on the white paper in any position and use your pencil to trace around it. Care should be taken not to move these objects while it is being traced.
3. Take a second object and lay it on the paper so that it overlaps the first. Trace around it. Continue to do this with other objects (an object can be traced more than once).
4. Erase any part of an object that goes under another object.
5. Use markers to color in the objects.

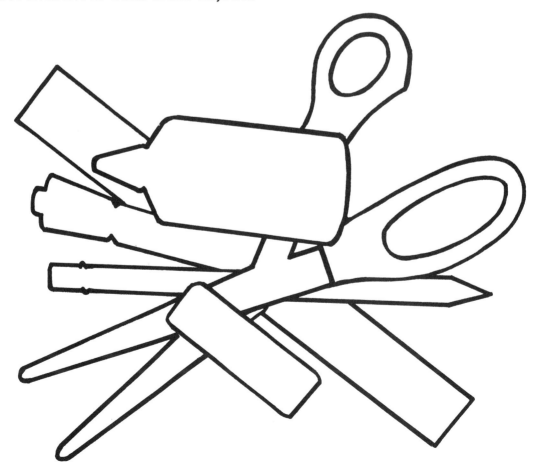

SCHOOL BUS

You can really get your students "moving" with this school bus project.

WHAT IS NEEDED
1. Mural paper (36" wide)
2. 18" x 24" oak tag paper (one per class)
3. Crayons

WHAT TO DO
1. Roll out the mural paper on the hallway floor.
2. Each child takes the oak tag paper and outlines it in black crayon onto the mural paper. Papers should be placed 3" between papers. Hold papers in a horizontal position. These rectangular outlines are the bus windows. (Leave 3' at the start of the mural paper for the bus driver and bus hood.)
3. Each child draws his/her face and shoulders inside one of the windows.
4. A committee of two or three students draws the bus outline. The top of the bus is the top of the mural paper. (Other details to add are: bus hood, wheels, headlights, bus number, tail lights, mirrors, bus driver, etc.)
5. Do the length of the bus, one class may want to do four small buses instead of one large bus.

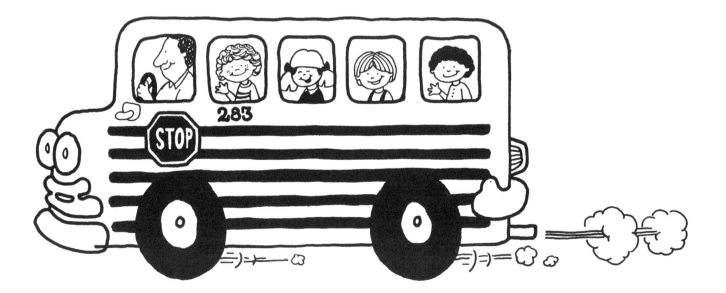

FOREGROUND/BACKGROUND

There are many clever ways in which students can make this art project "outstanding."

WHAT IS NEEDED

1. 12" x 18" oak tag paper
2. 4" x 8" oak tag paper
3. Ruler
4. Scissors
5. Crayons
6. Pencil

WHAT TO DO

1. Measure a 6" and 3" line from the bottom of the 12" x 18" oak tag paper.
2. Fold the paper on the 6" line and then fold the paper in the opposite direction on the 3" line. The large unfolded area of the paper will be the background of your picture.
3. Draw and cut out simple outline of a person from the 4" x 8" oak tag. This can be any type of person: farmer, fireman, sports figure, doctor, etc. This person will be the foreground.
4. Color the background and foreground adding detail.
5. Glue the figure to the bottom 3" section of the large paper.

READING THE NEWSPAPER

Where have you seen people reading the newspaper? This classic "man on the street" project will turn people's heads.

WHAT IS NEEDED
1. 12" x 18" manila paper
2. 4" x 6" newspaper section
3. Glue
4. Colored markers

WHAT TO DO
1. Discuss different locations where people might be found reading the newspaper.
 For example:
 - a) park bench
 - b) bus stop
 - c) livingroom
 - d) kitchen table
 - e) barber shop
 - f) on a train
2. Glue the newspaper section onto the manila paper. (Glue the two ends of the newspaper only, allowing the newspaper to stick out from the manila paper.)
3. With markers draw the person holding the newspaper and the background.

FOLDED PAPER DESIGN

This unusual origami project results in a design that has depth.

WHAT IS NEEDED

1. 16" x 16" white construction paper.
2. 3" x 3" origami papers (20 to 30 per student) all colors
3. Glue

WHAT TO DO

1. Fold each origami paper as follows:
 a) Fold in half
 b) Fold bottom two corners to the middle
2. Lay folded origami papers onto the white paper to form an interesting design. Try several arrangements until you get a design that you like.
3. Glue the origami papers to the white paper.

WINTER SPORT

Children will enjoy and relate to these winter sports.

WHAT IS NEEDED
1. 18" x 24" white construction paper
2. Watercolor sets
3. Brush
4. Cans (for water)
5. Pencil

WHAT TO DO
1. Discuss body positions of people when they are involved in a sport (skiing, sledding, ice skating, football, basketball).
2. Make a sketch of a person in a sport on the white paper. Do not sketch in any detail and do not press down hard with your pencil.
3. Paint the figure adding detail and background.

3-D WORDS

This is an introduction to linear perspective. Students will find it fascinating.

WHAT IS NEEDED
1. 12" x 18" white construction paper
2. Ruler
3. Markers (thin points)
4. Four 2" x 3" oak tag papers

WHAT TO DO
1. Explain the following terms in perspective:
 a) perspective (showing distance in a picture)
 b) horizon line (line formed where earth and sky meet)
 c) vanishing point (the point where things disappear)
2. Draw the horizon line through the middle of the paper (6" from the top of the paper).
3. Place a dot that represents the vanishing point on the middle of the horizon line (9" from the paper's edge).
4. Place the four oak tag rectangles near the bottom edge of the paper. They should be evenly spaced across the paper. Trace around them with a black marker.
5. Choose a letter with four letters in it.
6. Draw a large letter inside each rectangle. Make the letters fat and decorate them with markers.
7. Using a ruler, draw lines from the top two corners of each rectangle to the vanishing point. Be accurate.
8. Draw lines from one bottom corner of each rectangle to the vanishing point. Do not draw any line through a rectangle.
9. Now decorate the entire paper. Use your imagination.

WEAVING

A colorful wall hanging will be the result of this weaving.

WHAT IS NEEDED

1. Yarn – skeins of different colors
2. 5" x 10" cardboard
3. Scissors
4. Rulers
5. Masking Tape
6. Two 7" sticks

WHAT TO DO

1. Draw lines 1/4" in length, 1/2 inch apart at the top and bottom of the cardboard. Hold the cardboard vertically. Cut on the lines. This is your loom.
2. On one side of the loom (which will become the back) tape the yarn that has gone through the first cut in the loom.
3 Turn your loom over to the front side. Loop the yarn as shown through the cuts.
4. Tape the end of the yarn on the back as you did in #2.

5. Now you have completed the loom and are ready to weave.
6. Decide on a pattern for your weaving, for example: weave 10 red rows, 2 black rows, 7 white rows then repeat.
7. Take your first color of yarn and go over and under each strand of vertical yarn. When the end of the loom has been reached, weave back in the opposite direction. This time where you have gone over the vertical strand the first time, go under this time, etc.
8. When you have finished with one color, cut the yarn and begin with a new color.
9. When you have finished weaving, untape the two strands on the back.
10. Take weaving off of loom.
11. Weave one stick through the loops on the top of the weaving and tie yarn piece to the stick (this is the piece that had been taped to the back of the loom).
12. Weave the second stick through the bottom loops and repeat #11 procedure.

FISH MOBILE

Your student will get hooked on this project!

WHAT IS NEEDED

1. 1" x 18" Construction paper strips (12 or more per student) – all colors
2. Stapler
3. Scissors
4. String
5. Paper punch

WHAT TO DO

1. Staple two 12" x 18" strips one on top of the other. One staple should be 1" from the end and the other staple should be 6" from the other end.
2. Bend the 1" section to look like a fish mouth.
3. Curl the 6" section to look like a fancy fish tail.
4. The space between the two staples will be the body. Roll other 1" x 18" strips into cylinder shapes and staple them so that they retain that shape. (Cylinder should be just large enough to be able to place the stapler in the opening.)
5. Staple these cylinder shapes between the strips that form the body. The number of cylinders you will need depends on the fatness of the body.
6. Use a paper punch to make a hole in the top middle of the fish. Attach a string for hanging.
7. Student variations may include stapling a fancier tail, cylinders stapled inside cylinders and fins.

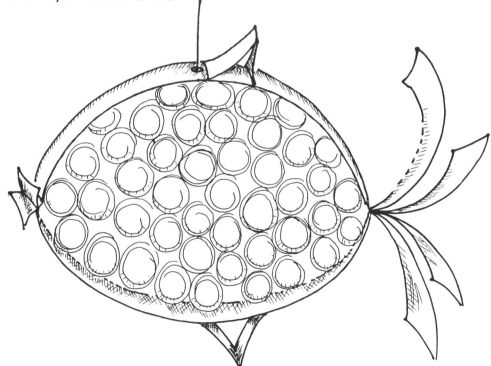

AFRICAN MASK

Learn about symmetry by creating an African mask. Remember this is not a Halloween mask but a beautiful African work of art.

WHAT IS NEEDED

1. Two 12" x 18" construction paper (a variety of colors but not pastel)
2. Construction paper scraps
3. Glue
4. Scissors
5. Pencil

WHAT TO DO

1. Check out books on real African masks from the library and show them to your class.
2. Fold one 12" x 18" construction paper in half lengthwise. This will become the mask face.
3. Draw half of your mask on the paper while it is still folded. Start and end on the fold. Do not make the mask too thin.
4. Open the paper and glue it to the second 12" x 18" construction paper.
5. Cut out eyes, paint marks, nose, mouth, earrings, wrinkles, eyebrows, feathers and hair from construction paper scraps. Put the same color scrap one on top of another and draw two of everything so that the mask will be symmetrical.

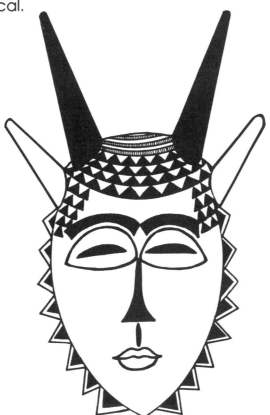

CLAY COIL POTS

Everyone enjoys making snake shapes in clay, and building with them is an easy method of creating a clay wall for this pot.

WHAT IS NEEDED
1. Water – base clay (baseball size)
2. Glaze
3. Brush 1/2"

WHAT TO DO
1. With your hands, roll out 8 to 12 (approximately 10" long) snake-like rolls. The rolls should be a little fatter than a pencil. These rolls will become the side of your clay pot.
2. Make the base of your pot by shaping a flat circle that is about 1/4" thick with a diameter of 3" to 5".
3. Now you are ready to begin building up the sides of your pot. Dip your finger in water and moisten the edge of the clay base. Place a coil around the edge, continue building up the sides of your pot by placing one coil on top of another. Moisten between each layer of clay and apply pressure to help the clay stick together.
4. See section on clay for firing and glazing.

Grade Four, Grade Five & Grade Six

PLANT

This plant drawing will provide growth for your students.

WHAT IS NEEDED
1. 18" x 24" manila paper
2. Colored markers
3. Pencil and eraser

WHAT TO DO
1. Bring 3 or 4 live house plants to school. Do not bring plants that have a lot of small leaves.
2. Scatter these plants around the room so that each child is within 6' of a plant.
3. Discuss the following
 a) leaf shape
 b) leaf veins
 c) position of stem
 d) thickness of stem
 e) overlapping leaves and stems
4. Use pencil to draw plant in detail.
5. Go over pencil lines with markers to add color.

LINE STUDY

Your students will line up to do this project!

WHAT IS NEEDED
1. 12" x 18" white construction paper
2. Ballpoint pen

WHAT TO DO

1. Draw one wavy line from one side of the paper to the other.
2. Draw a second line close to the first line. The lines may touch but not cross each other.
3. Continue to draw lines until the paper is filled with lines.
4. Experiment!
 a) Draw lines that are jagged instead of curved.
 b) Fill the paper with short lines that are curved or jagged.
 c) Have lines cross each other.

HALF MAGAZINE/HALF DRAWING

As students draw the missing half of this project, they will sharpen their sense of observation.

WHAT IS NEEDED
1. 12" x 18" white construction paper
2. Magazines with large pictures (*Life, Sports Illustrated*)
3. Scissors
4. Glue
5. Colored pencils

WHAT TO DO
1. Ask students to bring in magazines from home.
2. Have students tear out pages from the magazines that have large pictures on them.
3. Place all of the torn out pages in a central location. Allow students to look through this collection of pictures and choose a picture he/she likes.
4. Cut the paper that was chosen in half.
5. Glue the picture half onto the white paper.
6. Use colored pencils to draw the missing half of the magazine page.

COAT HANGER CLOWN

This clown will hang around your classroom for a long time!

WHAT IS NEEDED
1. Two metal coat hangers
2. Six 12" x 18" construction paper
3. Masking tape
4. Scissors
5. Glue
6. Paper punch
7. String

WHAT TO DO
1. Discuss different clown types (sad, happy, silly, etc.). Describe different ways they could look (big nose, curly hair, oversized shoes, etc.).
2. Tape the two coat hangers together at the bottoms.
3. Draw and cut out two heads. (Place one paper on top of another so that you will cut out two heads at the same time.)
4. Fold two papers in half and draw a hand on one half of each paper.
5. Cut out the hands with the papers folded. You now have four hands.
6. Fold two papers in half and draw a foot (or shoe) on one half of each paper.
7. Cut out the shoes with the paper folded. You now have four shoes.
8. Tape one head, two hands and two feet on one side of the hangers.
9. Glue the second set of hands, feet and head on top of the first set on the other side of the hangers.
10. With scraps cut out and glue on the details (facial features, hat, hair, ring, shoe laces, etc.).
11. Use the paper punch to make a hole in the top of the head. Attach a string for hanging.

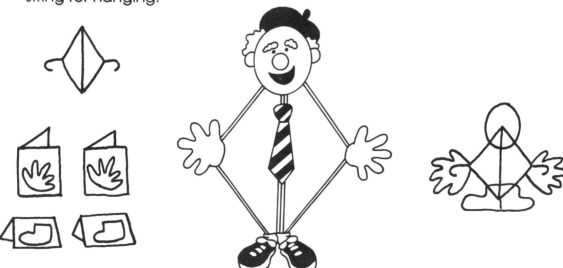

STAINED GLASS

Students will enjoy the look achieved from this simulated stained glass window project.

WHAT IS NEEDED

1. 12" x 18" matt board, white
2. India Ink
3. Glue
4. Watercolors
5. Brushes
6. Cans
7. Pencils

WHAT TO DO

1. Sketch your idea on the matt board. The idea should be simple and large. Ideas that are colorful are especially effective (parrot, butterfly, balloons).
2. Empty 6 (4 oz.) glue bottles in a can. Add enough India Ink to turn the glue to a charcoal gray. Mix. The consistency should allow for an even flow through the glue bottle opening. Pour the ink/glue mixture back into the glue bottles.
3. Go over the lines of your sketch with ink mixture. (This is to simulate the lead found in stained glass windows.)
4. Allow to dry until the next art lesson.
5. Paint between the "lead" lines. Cover the entire matt board with paint.

FELT WALL HANGING

This colorful creation will brighten a wall in your student's home.

WHAT IS NEEDED

1. 9" x 12" manila paper
2. 9" x 12" felt – all colors (one per student)
3. Felt scraps (the ideas will be cut from these so you will need quite a few pieces)
4. Scissors
5. glue
6. Pencil
7. Ballpoint pen

WHAT TO DO

1. Draw your idea on the 9" x 12" manila. Some ideas are: boats, children at play, etc.
2. Cut out the objects in your picture and trace around them on the felt pieces using a ballpoint pen.
3. Cut out the objects from the felt.
4. Glue the flat objects to a 9" x 12" background felt.

FOIL RELIEF

This metallic relief is very effective yet easy to do.

WHAT IS NEEDED

1. 9" x 12" manila paper
2. Two 9" x 12" cardboard
3. Tinfoil (one roll per class)
4. India Ink
5. Liquid Soap
6. Glue
7. Pencil
8. Scissors
9. Brushes
10. Cans
11. Paper towels

WHAT TO DO

1. Draw one object on 9" x 12" manila (bird, car, leaf, etc.). Do not draw in a background.
2. Cut it out and trace onto the 9" x 12" cardboard.
3. Cut out the cardboard object.
4. Glue the cut out shape onto the second cardboard.
5. Cut a sheet of tinfoil (16" long).
6. Lay the tinfoil on top of the cardboard and gently (if you tear the tinfoil, get a new sheet) press it around the cardboard shape. Keep the tinfoil in one piece.
7. Tape the tinfoil edges to the back of the cardboard.
8. Pour 1/4 cup (approximately) India Ink into a can. Add 4 or 5 drops of liquid soap. (This makes the ink adhere to the tin foil.) Mix.
9. Brush the India Ink mixture over the tinfoil relief.
10. When the ink has dried, take a paper towel and rub over the raised surface.

OPEN DOOR

Science fiction writers could create a script from what your students can do with this project.

WHAT IS NEEDED

1. 18" x 24" manila
2. 12" x 24" manila
3. Colored markers
4. Masking tape

WHAT TO DO

1. Tape one vertical side of 12" x 18" manila to the 18" x 24" manila. The small paper should be centered on the 18" x 24" paper.
2. The small paper represents a door to the outside of a building that opens so that you can see inside.
3. Use a black marker to outline the small paper onto the large paper (do this on the three sides that are not taped). This serves as a door frame.
4. Determine what kind of building this is – barn, house, garage, restaurant etc. Then add lots of detail.
5. Put your imaginations to work! Use your markers to add detail to the outside of the buildings and the inside (when the door is open).

PAPIER MACHÉ HEAD

The papier maché process is always a mess – but so much fun.

WHAT IS NEEDED

1. Paper plate
2. Newspaper
3. Paper Towels
4. Wheat Paste
5. Large cans (for mixing wheat paste)
6. Spoon
7. Tempera paint
8. Brushes
9. Egg Cartons (paint holder)
10. Yarn
11. Construction paper scraps
12. Masking tape
13. Scissors

WHAT TO DO

1. Decide on what kind of face you want to make (animal, clown, monster, etc.).
2. Roll, fold or bunch up newspaper into the shape you want for a particular part of the face. For example, a short rolled up newspaper could be an eyebrow. Tape it so that it does not lose its shape then tape it onto the head (paper plate).
3. After you have taped on all the parts you want to stand up (nose) or out (ears), mix the wheat paste with water and tear a pile of newspapers into strips approximately 1" x 6".
4. Dip the newspaper strips into the wheat paste and lay them in a crisscross fashion onto the face. Continue doing this until you have three layers covering the face.
5. Tear up some paper toweling also approximately 1" x 6". Lay one coat of paper towels on top of the face. This is your final layer. The covering with the paper towels makes an easier painting surface.
6. Allow this to dry for one week.
7. Paint the face.
8. After the paint is dry you might want to add yarn or paper to your face (yarn hair, yarn bear, paper ears, paper teeth etc.).

ONE POINT PERSPECTIVE

Get on track with this railroad perspective.

WHAT IS NEEDED
1. 12" x 18" white construction paper
2. Ruler
3. Marker (thin points)
4. Pencil and eraser

WHAT TO DO
1. Explain the following terms of perspectives:
 a) perspective (showing distance in a picture)
 b) horizon line (line formed where earth and sky meet)
 c) Vanishing point (the point where things disappear)
2. Draw the horizon line through the middle of the paper (6" from the top of the paper).
3. Place a dot that represents the vanishing point on the middle of the horizon line (9" from paper's edge).
4. Use the ruler to draw railroad tracks. Lines should start on the vanishing point and widen as they reach the bottom of the paper.
5. The spaces between the railroad ties should get larger as they near the bottom of the paper. The lines should be parallel to the horizon line.
6. Draw the telephone that is closest and therefore the largest. This pole should cross the horizon line and come close to the top and bottom of the paper.
7. Draw two lines (eventually to be erased) from the top and bottom of the telephone pole to the vanishing point. The height of the other poles will come between these two lines.
8. The spaces between the poles should get smaller as they go towards the vanishing point.
9. Connect the poles with telephone wires.
10. Use your imagination to make this picture interesting. Remember to make things smaller as they go towards the horizon line.

CLAY FLOWER HOLDER

Here is a unique flower holder that will help to brighten many rooms.

WHAT IS NEEDED

1. Water-base clay (size of two baseballs)
2. Rolling pin
3. Wooden clay tool (pencil shaped)
4. Spatula
5. Two rulers
6. Newspaper
7. Glaze
8. Brush 1/2"

WHAT TO DO

1. Place clay between two rulers.
2. Use a rolling pin to roll out the clay. Keep the rolling pin above the rulers to make the clay an even thickness.
3. Use your clay tool to cut out two shapes from this rolled out clay.

 a) First shape – 4" wide, 8" tall
 Use the clay tool to make a hole
 near the top (for hanging). Round
 off the top corners.

 b) Second shapes – 5" wide, 6" tall

4. Roll up (approximately 1/2 sheet) a newspaper cylindrical in shape.
5. Lay the newspaper on top of the first clay shape, but do not let the cylinder go off the bottom or sides. Place the second clay shape on top of the first clay shape so that the bottoms of both shapes are even.
6. Use your thumb to press down and crimp together the bottom and two sides of the two clay shapes.
7. With your clay tool draw a design on your flower holder.
8. After the clay has air-dried, remove the newspaper. The pocket will not keep its shape.
9. See section on clay for firing and glazing.

SHOE DRAWING

Put your foot down and insist on good observation.

WHAT IS NEEDED
1. 12" x 18" manila paper
2. Pencil and eraser (soft lead pencil)

WHAT TO DO
1. Have students take off one shoe and place it on the table in front of them.
2. Discuss shoe proportions.
 - a) How large is the opening where the foot goes in compared with the rest of the shoe.
 - b) Is the sole of the shoe fat or thin.
 - c) Find the high and low point of the shoe.
3. Notice details of the shoe:
 - a) shoelaces
 - b) shoe crown
 - c) words on the shoe
 - d) shoe trade marks
 - e) does the toe touch the table?
 - f) is the heel worn?
 - g) different textures
 - h) is the heel curved or straight?
4. Hold the paper horizontally (vertical if the boot or any tall shoe).
5. Draw the shoe larger than life-size.
6. Draw lightly at first until the shoe looks the way you want it to look, then go over your drawing to make it dark (soft lead pencil).

CHARCOAL DRAWING

This charcoal drawing promotes the feeling of depth with the three techniques of overlapping, placement and shading.

WHAT IS NEEDED
1. 12" x 18" gray construction paper
2. Charcoal
3. White chalk
4. Pencil

WHAT TO DO
1. With a pencil, draw three or four simple vases that overlap each other. Make some vases short and some tall.
2. The farther away the vases are, the farther they should be from the bottom of the paper.
3. Have your source of light coming from the left or right.
4. If your light is coming from the left, the left side of each vase should be lightest in value (white chalk).
5. Gradually have your vases get darker (charcoal) as you move to the right, ending in black.
6. The opening of the vases should be black.
7. Draw a horizontal line behind the vase to represent the table edge.

PRINT

WHAT IS NEEDED

1. 9" x 12" manila paper
2. 9" x 12" white print paper
3. 10" x 14" white construction paper
4. Styrofoam meat trays (trimmed to 9" x 12")
5. Printers ink – any dark color
6. Brayers
7. Metal tray – approximately 12" x 14"
8. Pencil
9. Scissors
10. Glue

WHAT TO DO

1. Draw your idea on the manila paper. This idea should have detail. (Examples: flowers, people, scenes.)
2. Trim off the upturned edges from the styrofoam trays.
3. Use your pencil to transform the sketch to the styrofoam. Press down hard enough to make a fairly deep dent but do not make a hole in the styrofoam.
4. Squeeze some ink onto the metal tray.
5. Use the brayer to spread out this ink and coat the brayer evenly with ink.
6. Roll the inked brayer on top of the styrofoam drawing. Coat the styrofoam entirely.
7. Turn the styrofoam upside down on the 9" x 12" white paper. Gently rub the styrofoam with the heel of your hand.
8. Carefully lift off the styrofoam.
9. Look at your finished print. It's not too late to make some additions! You may go back to the styrofoam and draw in additional lines. (Then repeat the printing process.)
10. When the print is dry, glue it to a 10" x 14" construction paper for background framing.

TWO POINT PERSPECTIVE

This project calls for accuracy as well as imagination.

WHAT IS NEEDED
1. 12" x 18" manila paper
2. Ruler
3. Pencil and eraser

WHAT TO DO
1. Hold the paper in a horizontal position. Draw the horizontal line 6" from the top of the paper.
2. Place the two vanishing points on the horizon line at the edge of the paper.
3. Find the middle of the horizon line (9" from the paper's edge) and place a dot there. Hold your ruler in a vertical position on top of that dot. Your ruler should be even with the top and bottom of the paper. With the ruler in that position draw a vertical line from the 3" mark to the 9" mark. This line will become the corner of your house.
4. Place your ruler at the top of the line you have just drawn and on vanishing point #1. Draw a line connecting these two points.
5. Do the same to the bottom of the line and vanishing point #1.
6. Repeat the process on the second half of the paper going to vanishing point #2.
7. Draw vertical lines between the top and bottom of the lines you have just drawn. Where you put these two lines will determine how big your house is going to be.
8. It's time to do some erasing. Erase the horizon line when it goes through the house. Erase the parts of the four lines (#4, 5, 6) that are outside of the building.
9. The next step is to make the point on the roof. On one side of the house draw two lines from corner to corner.
10. Draw a vertical line that passes through the two lines where they intersect. This line should be 1" from the top of the paper.
11. Draw two lines from the top of the line you have just drawn to the corners of the side of the house.
12. Now draw a line from the roof point to vanishing point #1 (or #2 if the roof point is on the other side).
13. The final line of the roof is a slanted line drawn from the top of the roof to the back corner of the house.

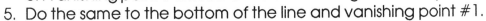

14. Now you are ready for doors and windows. Start all doors and windows with vertical lines. The length of the line is determined by the height you want the door or window to be.
15. The tops and bottoms of the windows and doors go to the vanishing point on the right if they are on the right side of the building and to the left vanishing point if they are on the left side of the building.
16. Finish the doors and windows with a second vertical line.
17. Use your imagination in completing this house (trees, shrubs, people, etc.).

CORRUGATED CARDBOARD

Terrific texture and vivid color make this project a favorite with students.

WHAT IS NEEDED

1. 18" x 24" manila paper
2. 18" x 24" white poster board
3. Corrugated cardboard (There are twelve different colored 12" x 18" sheets in a package, you will need approximately ten packages per class.)
4. Scissors
5. Glue
6. Pencil

WHAT TO DO

1. Sketch your idea on 18" x 24" manila. Objects in the drawing should be large, details are hard to cut out of the cardboard. Almost any idea will be effective, from a circus scene to a plate with food on it.
2. Cut out, by color, the objects in your sketch.
3. Trace around the cut out objects onto the back of the corrugated cardboard.
4. Cut out the cardboard objects.
5. Glue them onto the poster board.
6. When gluing, cardboard may be glued on top of cardboard (for example: eyes on the face).

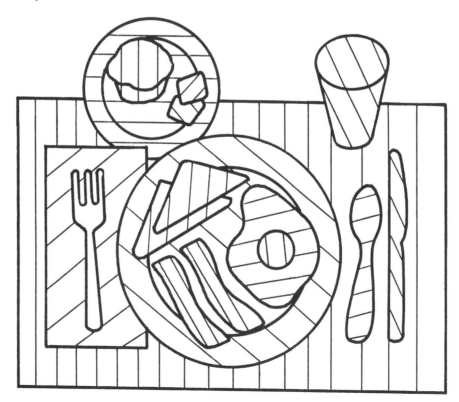

TIE DYE T-SHIRT

These '60s style T-shirts will be more popular than ever after this project.

WHAT IS NEEDED
1. Cotton T-shirt, white
2. Red, yellow and blue cold water dye (3 packages of each)
3. Three buckets
4. 2 or 3 rolls of heavy string
5. Scissors

WHAT TO DO
1. Choose a warm, sunny day because you will do this project outside.
2. Warn your students about possible stains to their clothing. Advise them to wear old clothes or smocks.
3. Place your hand inside the shirt. Poke one finger into the fabric to make a protrusion. Remove finger. Wrap four layers of string around the protruding finger in two or three places. Wrap it tightly.
4. Repeat this process anywhere on the shirt that you want a sunburst effect.
5. Mix each dye in a separate bucket according to package directions.
6. Dip each tied section into the dyes in the following order: yellow first, red second, blue last. This helps keep the colors pure. Hold the shirt in the dye for two – three minutes
 Yellow Red Blue
7. Carefully cut the string from the shirt. Throw away the string.
8. Lay the shirts on the lawn to dry. Place rocks on edges of the shirt to prevent them from being blown away.
9. When students get home they should iron the shirt to set the color. Wash separately in cold water.

PERSON IN MOTION

Your students will fly into action with this motion project.

WHAT IS NEEDED

1. 18" x 24" white construction paper
2. 6" x 9" oak tag
3. Felt markers (thin point, all colors)
4. Felt markers, (fat point, all colors)
5. Scissors
6. Pencil

WHAT TO DO

1. On the blackboard make a list of people in motion. (For example: skier, bowler, diver, runner, tennis player etc.)
2. Choose one person in motion and draw him/her on the oak tag. Draw your figure as large as possible. Outline the figure. Do not add any details.
3. Cut out the figure.
4. Lay the figure on top of the white paper and trace around it with thin markers.
5. Move the figure slightly, allowing it to overlap the first figure. Trace around it. Continue to trace around the figure (eight to twelve times). Each time overlap it on the previous outline. By doing this you will get a feeling of motion.
6. Draw an interesting background using the fat markers.

EYEGLASSES

Elton John never had it so good! See if you can exceed his fabulous specs.

WHAT IS NEEDED

1. 12" x 18" oak tag paper
2. Scissors
3. Markers
4. Glue
5. Glitter
6. Pencil
7. Colored cellophane

WHAT TO DO

1. Draw "regular" life size eye glasses on 12" x 18" oak tag. The stems and glass rims should not be smaller than 1/2" wide.
2. Take a pencil and make designer glasses. Color with marker.
3. Cut out.
4. Glue cellophane behind the eye openings.

FLOWER DROP PAINTING

Many flowers will bloom in this watercolor.

WHAT IS NEEDED
1. 18" x 24" white construction paper
2. Watercolor set
3. Watercolor brush
4. Crayons
5. Sponge
6. Can for water

WHAT TO DO
1. Use your crayons to draw a large vase near the bottom of your paper. Paper may be held vertically or horizontally.
2. Wet the entire paper with a sponge.
3. Fill a brush with water and paint and let the paint drip from the brush onto the paper above the vase. The paint will spread because of the wet paper surface and abstract flowers shapes will be formed. Repeat this process until you have enough flowers for your vase.
4. When the paper is dry, paint in the leaves.

SILHOUETTES

These silhouettes are highlighted by an unusually colorful background.

WHAT IS NEEDED
1. 11" x 11" construction paper, black
2. 12" x 12" construction paper, white
3. 11" x 11" paper towels, white
4. Paper dye, red, yellow, blue ("Dippity Dye" makes an excellent dye)
5. Scissors
6. Glue
7. Cans, 3 large
8. Pencil
9. Newspaper

WHAT TO DO
1. In the cans, mix each dye with water (mix according to package directions).
2. Fold the paper towel 4 or 5 times any way you want. (One way would be to fold it like an accordion.)
3. Dip the folded paper towel (one side at a time) into each dye. Do not put one dye on top of another but allow edges to blend together. Try to cover most of the towel with dye.
4. Unfold paper towels and lay them on top of newspapers to dry.
5. Draw an outline of 2 or 3 objects on the black paper (for example: boats and sun).
6. Cut out these objects and glue them onto the dry paper towel.
7. Glue the picture to the white paper. The white paper will serve as a backing and frame.

CLAY ANIMAL

With this assortment of animals you can create your own zoo!

WHAT IS NEEDED
1. Water-base clay (the size of two baseballs)
2. Glaze
3. Brushes

WHAT TO DO
1. Give the students the opportunity to see different kinds of animals (films, slides, books) then select one to make.
2. Form the body first.
3. After the body has been made, pull out the neck, head, tail and legs. Try to keep the clay in one piece rather than breaking it up into pieces and reassembling.
4. Use clay tools for details: eyes, fur, etc.
5. Fire and glaze the animals. (See clay section.)

GIFTED CLASSES

CLOWN MAGAZINE COLLAGE

Ringling Brothers has a clown college and your students will have a clown collage.

WHAT IS NEEDED

1. 9" x 12" white construction paper
2. Scissors
3. Magazines
4. Glue
5. Pencil
6. Marker – black (fat point)

WHAT TO DO

1. Discuss clowns' faces. (Nose, eyes, mouth, hair, hat, expression etc.)
2. Draw a clown's face on the white paper.
3. Cut out colored magazine pages into shapes (circle, squares, or triangles) that are approximately 1/2" in diameter. Keep the colors separate.
4. Glue overlapping magazine pieces to color the clown's face. Be sure to make each facial feature a new color.
5. As an option, you may use a black marker to outline eyes, etc.

BALSA WOOD ANIMAL

Hang these colorful animals in your window to brighten your room.

WHAT IS NEEDED

1. 12" x 18" manila paper
2. Tissue paper, all colors, 2 packages
3. Waxed paper, one roll
4. Scissors
5. Glue
6. Balsa wood 1/4" x 1/8" x 36"
7. Pencil
8. String – 1'

WHAT TO DO

1. Draw a large animal outline, using straight lines, on manila paper. Keep it simple!
2. Lay a sheet of waxed paper on top of the drawing.
3. Cut and glue balsa strips together on top of the waxed paper so that they are directly above the sketch. (The sketch shows through the waxed paper but will not stick to it.)
4. Reinforce large open areas with strips of wood glued from side to side.
5. Let glue dry (24 hours).
6. Peel off the waxed paper from the balsa outline.
7. Glue tissue paper between spaces of the wood. Use different colors in each space.
8. Attach string for hanging.

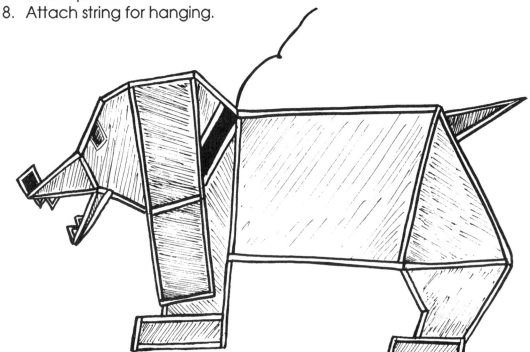

MOBILE

Turning like a Caldor mobile, these hangings will attract attention.

WHAT IS NEEDED
1. Wire (18 gauge) approximately 36" per student
2. Colored tape, 4 rolls per class
3. String, 2'
4. Scissors

WHAT TO DO
1. Bend wire until you create a shape that is pleasing to you.
2. Twist the two ends of the wire together.
3. In 3 or 4 spaces between the wire, stretch tape from one side to the other. This should be done at the loop ends.
4. In those same spaces, stretch tape on the opposite sides so that the sticky sides of the tape are facing each other.
5. Attach string for hanging.

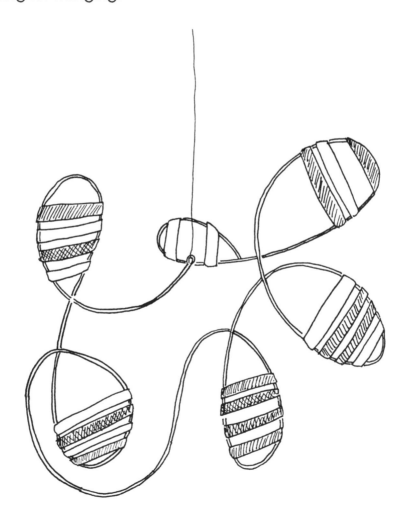

HALF AND HALF

These two halves will come together to make an interesting whole.

WHAT IS NEEDED
1. 12" x 18" construction paper, all colors
2. 6" x 18" construction paper, all colors
3. Scissors
4. Glue
5. Pencil

WHAT TO DO
1. With one line draw 1/2 of person (policeman, farmer, astronaut, etc.) on the 6" x 18" paper. Start and end the line on the right edge.
2. Place the 6" x 18" paper on top of the 12" x 18" paper so that the two left sides are even.
3. Cut the half person and flip it onto the second half of the 12" x 18" paper.
4. Place the cut out person so that the beginning and ending of the line touch and a whole person is formed.
5. Details can be added by making additional cuts in the 1/2 figure on the right and flipping them back onto the left.
6. Glue the cut out shapes to the 12" x 18" paper.

CARDBOARD RELIEF

This painting has depth!

WHAT IS NEEDED

1. 12" x 18" cardboard
2. Cardboard strips 1/2" wide, various lengths
3. Glue
4. Scissors
5. Tempera paint
6. Brushes, 1/4"
7. Cans for water
8. Pencil

WHAT TO DO

1. Draw a simple picture or design on the 12" x 18" cardboard (car, building, etc.). Keep all lines straight.
2. Cut the cardboard strips to fit the lines.
3. Glue the cardboard strips on top of the lines. (Cardboard should be standing on edge.)
4. When the glue is dry, paint.

BURLAP WEAVING

Weave magic when students brighten dull burlap with ribbon and yarn.

WHAT IS NEEDED

1. 12" x 18" burlap
2. Two 14" long dowels
3. Large needle
4. Yarn, 6 skeins of different colors (per class)
5. Ribbon – a variety of widths and colors
6. Scissors

WHAT TO DO

1. Hold your burlap in a vertical position.
2. Fold the top edge over the dowel. Use the yarn and needle to stitch a line across the burlap to hold the dowel in place.
3. Pull out burlap threads from the side to provide space for weaving ribbon or yarn.
4. Weave the yarn or ribbon through the open spaces until you have the desired results.
5. Fold up the bottom edge of the burlap and attach the second dowel. (The same method that you used for the first dowel.)

3-D REPLICA

You can make an object out of papier mache and have an Andy Warhol look-alike!

WHAT IS NEEDED

1. 18" x 24" oak tag
2. Boxes – many, all sizes (cylinders, squares, rectangles)
3. Wheat paste
4. Cans (for mixing wheat paste)
5. Large spoon
6. Masking tape
7. Scissors
8. Paper towels
9. Brushes (1/4" and 1/2")
10. Tempera – all colors

WHAT TO DO

1. Select a 3-D object that interests you. (For example: toothpaste tube, gum package, etc.)
2. Tape boxes together and/or bend, cut and tape oak tag to make the shape of the object.
3. Dip paper towel strips (approximately 2" x 12") into wheat paste and place them around the object until you have three layers covering it.
4. Dry.
5. Paint the 3-d object to look real.

CIRCLE DESIGN

Round and round they go – where they stop becomes an art project!

WHAT IS NEEDED
1. 18" x 24" construction paper – all colors
2. 6" x 6' oak tag
3. 2-12" x 18" construction papers – all colors
4. Compass
5. Rulers
6. Pencil

WHAT TO DO
1. With a compass draw a circle (6" diameter) on the oak tag. Cut it out. This will be the pattern.
2. Choose (2) 12" x 18" construction paper colors that go well together.
3. Trace around the circle pattern on these two papers to make 12 circles. Cut them out.
4. Cut some circles in half and some in quarters.
5. Arrange these three shapes (● ◡ ◗) on the large paper to make a symmetrical design.
6. Glue in place on the 18" x 24" paper.

Marbelized Paper

Create fantastic swirling patterns today!

What is Needed

1. 9" x 12" white construction paper
2. Acrylic paint – red, yellow, blue
3. Liquid starch – 1 bottle per class
4. Shallow pan (a little larger than the paper)
5. Comb (wide space between teeth preferred)
6. Eye dropper

What to Do

1. Pour liquid starch into pan (1" deep).
2. Using the eye dropper, dribble a few drops of paint (red, yellow, blue) on the surface of the starch.
3. Use a comb to slightly swirl the paint.
4. Carefully float the white paper on top of the liquid.
5. As soon as the paper gets wet, lift the paper.
6. Dry.

PAPER RELIEF

Behold! Cut and fold, cut and fold!

WHAT IS NEEDED
1. 12" x 12" white construction paper
2. Cardboard (to fit under paper)
3. X-Acto knife
4. Pencil

WHAT TO DO
1. Discuss safety precautions when using a knife:
 a) Never pull the knife towards your hand.
 b) No fooling around.
2. Lay paper on top of cardboard to prevent cutting of table surface.
3. Draw these lines over the entire paper surface. Lines may vary in size.
4. Cut on the lines you have drawn.
5. Bend the cut areas so that they stand up to make a relief.

CLAY WIND CHIMES

These chimes will set the right tone in your classroom!

WHAT IS NEEDED

1. Water-base clay (size of two baseballs)
2. Glaze
3. Brush 1/2"
4. Rolling Pin
5. Clay Tool (pencil shaped)
6. 12" leather card
7. Nylon thread (one spool per class)
8. Scissors
9. Two rulers
10. Masking Tape
11. Metal spatula

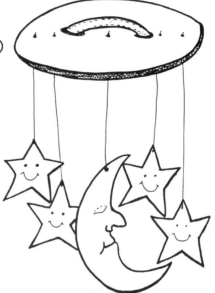

WHAT TO DO

1. Place the clay between two rulers and roll out with the rolling pin. Rulers make the clay an even thickness. Use the metal spatula to lift the clay from the table surface.
2. From the rolled out clay, cut out (using the clay tool) one 4" x 7" oval and five 4 1/2" x 2 1/2" rectangles.
3. With the clay tool, cut out shapes from the five rectangles. (Examples: letters, abstract shapes, musical notes, fruit, etc.)
4. With the clay took, make the following holes in the oval. The top two holes should be large enough for the leather cord to pass through.
5. Make one hole in the top of each of the five smaller shapes. The hole should be large enough for the nylon thread to pass through.
6. Fire and glaze the clay (see clay section).
7. Thread the leather cord through the top holes and tie.
8. Cut five 8" lengths of nylon thread.
9. Put one end of the nylon thread through the hole in the top oval and the other end in one of the five small shapes. Repeat this process for each of the other four small shapes. Tie double knots in the nylon at the top and bottom.
10. See section on clay for firing and glazing.

BULLETIN BOARDS

September Bulletin Board

School Name Explosion

Since this is the only month you will have to display your own artwork, make it explosive!

What is Needed

1. 18" x 24" construction paper, dark blue (enough to cover the bulletin board)
2. 4" square red (30) construction paper
3. 4" square white (30) construction paper
4. 1" x 24" strips of white construction paper
5. 1" x 24" strips of red construction paper
6. 5" x 7" white construction paper (one for each letter in the school name)
7. Stapler

What to Do

1. Cover the board with blue construction paper.
2. Cut out letters of school name from the 5" x 7" white paper.
3. cut out stars and circles from the red and white squares (make some large and some small).
4. Leave some of the red and white paper strips 24" long and cut others in varying lengths.
5. See accompanying drawing for assemblage.

OCTOBER BULLETIN BOARD

3-D Paper Masks (Grade 3)
What is October without a Halloween mask on your bulletin board.

WHAT IS NEEDED

1. 12" x 18" construction paper (all colors)
2. Construction paper scraps (all colors)
3. Scissors
4. Glue
5. Stapler
6. String
7. Paper punch

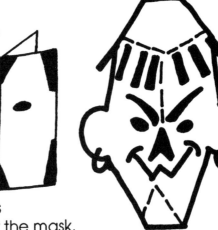

WHAT TO DO

1. Discuss different Halloween characters
2. Choose a construction paper color for the mask.
3. Fold the paper in half lengthwise.
4. With the paper still folded, draw, then cut these shapes that are darkened.
5. Open the paper. Slightly overlap the V section and staple. Do the same to the bottom V section. This will make the mask three-dimensional.
6. From the paper scraps, draw and cut out hair, eyebrows, mouth, earrings, etc. Some of the paper may be folded or curled.
7. Glue the different parts onto the mask.
8. Feathers, pip cleaners and other extras may be added.

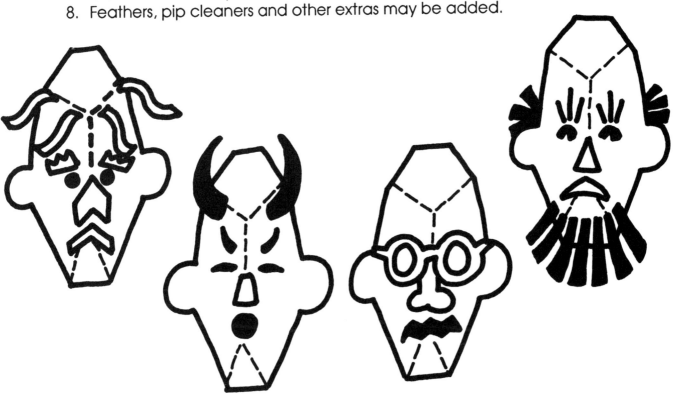

NOVEMBER BULLETIN BOARD

Turkeys (Gifted Classes)
Be thankful that you have students to do this turkey bulletin board.

WHAT IS NEEDED

1. 18" x 24" black construction paper (enough to cover the bulletin board)
2. 3" x 18" orange construction paper (enough to outline the bulletin board)
3. 9" x 18" gray construction paper (2 per student)
4. 9" x 12" brown construction paper (2 per student)
5. 12" x 18" white construction (1 per student)
6. Construction paper scraps (every color but black)
7. Scissors
8. Glue
9. Stapler
10. Pencil

WHAT TO DO

1. Draw the body of a turkey from the gray or brown paper. Ask some students to make their turkeys large, some medium and some small.
2. Use the construction paper scraps for the head, neck, feathers, legs etc. Cut out these body parts and glue them to the body.
3. Cover the bulletin board with black paper and outline it with the orange paper strips.
4. Cut out a moon and stars from the white paper.
5. Cut out trees (trunks and branches only – no leaves) from the gray and brown paper. Make the trees different sizes.
6. Staple small turkeys and trees near the top of the board. As you came closer to the bottom of the board staple the larger turkeys and trees.

DECEMBER BULLETIN BOARDS

Happy Holidays (Grade 4)
This village scene will give a cozy holiday feeling to all.

WHAT IS NEEDED

1. 18" x 24" construction paper – dark blue (enough to cover the bulletin board)
2. 9" x 12" construction paper – all colors (10-15 sheets of each color per class)
3. 5" x 7" white construction paper
4. 5" x 7" black construction paper
5. Cotton
6. Scissors
7. Glue
8. Stapler

WHAT TO DO

1. Have each student cut out construction paper (no blue) to make a house. House size should vary in sizes from approximately 6" x 8" to 2" x 4".
2. Discuss details that could be added to the house:
 a) chimney
 b) shutters
 c) windows in doors
 d) wreaths on doors
 e) house numbers

 Cut these out of construction paper and glue them on the house.
3. each student should select one or two of the following to make:
 a) trees (bare branches or evergreens) that are different sizes
 b) Shrubs
 c) moon and stars
4. Cut out two sets of letters, one set white and one black for the words
 HAPPY HOLIDAYS!
5. Cover the board with blue paper.
6. Staple on cotton for snow.
7. Staple large houses close to the bottom of the bulletin board and the smaller houses closer to the top to show depth. (Overlap some of the houses.)
8. Staple on the stars and moon.
9. Staple on letters so that the black letters are partially behind the white.
10. Staple small bits of cotton over the entire board for falling snow.

JANUARY BULLETIN BOARD

Snowmen (Grade 1)
Brr-r it's January so get this bulletin board up and "Let It Snow"

WHAT IS NEEDED

1. 18" x 24" dark blue construction paper (enough to cover the bulletin board)
2. 18" x 24" white construction paper – 2 per student
3. 9" x 12" white construction – 2 per student
4. 8" x 11" red – 1 per student
5. Construction paper scraps (all colors)
6. Cotton
7. Scissors
8. Glue
9. Stapler

WHAT TO DO

1. Draw and cut out two large snowball shapes on each of the large white papers. Glue the two shapes together to make the form of a snowman.
2. Glue cotton to the snowman so that it is completely covered.
3. cut out arms from the two 9" x 12" sheets of white paper (do not glue on cotton). Glue the arms to the body.
4. Use construction paper scraps for scarf, buttons, tie, hat, eyes, nose, mouth, etc. Glue these onto the snowman.
5. Fold 8" x 11" red paper in half to make sheet music. (Bend arms so that music will stand away from the body.)
6. Staple snowmen to the bulletin board.
7. These additional things could be added to the board:
 a) street lamp
 b) snow
 c) words "Let It Snow"

FEBRUARY BULLETIN BOARD

"Kindergarten Sends Their Love" (Kindergarten)
Kindergarten hearts will not be broken this Valentine's Day.

WHAT IS NEEDED
1. Wrapping paper (Valentine's Day) enough to cover the bulletin board
2. 22, 3" x 5" pink, white or red construction paper (whichever color goes best with the wrapping paper you have chosen)
3. 9" x 12" white construction paper (one per student)
 9" x 12" pink construction paper (one per student)
 9" x 12" red construction paper (one per student)
4. Lace doilies, white (1 or 2 per student)
5. Scissors
6. Glue
7. Stapler
8. Markers (all colors)

WHAT TO DO
1. Put all of the mentioned supplies (except wrapping paper and 3" x 5" rectangles) on their tables. Design the fanciest Valentine you can imagine.
2. Cut out letters for **KINDERGARTEN SENDS THEIR LOVE** from the 3" x 5" paper.
3. Cover the board with the wrapping paper.
4. Staple letters and Valentines to the bulletin board.

MARCH BULLETIN BOARD

"Hooray For Spring" (Special Education)
These flowers will help bring spring inside your school!

WHAT IS NEEDED
1. 18" x 24" light blue construction paper (enough to cover the bulletin board)
2. 9" x 12" fluorescent pink paper (one per student)
 9" x 12" fluorescent yellow paper (one per student)
3. 6" x 18" fluorescent green paper (one per student)
4. 15 – 3" x 5" fluorescent yellow paper
5. Scissors
6. Glue
7. Stapler

WHAT TO DO
1. With the pink and yellow fluorescent papers make flower (blossoms only).
2. With the green fluorescent paper make the stems and leaves. Glue the two together.
3. Cut out letters from the 3" x 5" yellow papers to spell **HOORAY FOR SPRING**.
4. Staple light blue paper to cover the board.
5. Staple flowers and words to the bulletin board.

APRIL BULLETIN BOARD

Don't let the rain dampen your spirits this spring! (Grade 2)

WHAT IS NEEDED
1. 18" x 24" gray construction paper (enough to cover the bulletin board)
2. 12" x 18" yellow construction paper (2 per student)
3. 9" x 12" green construction paper (4 per class)
4. 12" x 18" construction paper (all colors) 1 per student
5. Construction paper scraps
6. Tinfoil
7. Glue
8. Scissors
9. Stapler

WHAT TO DO
1. Tear one yellow paper to make a duck's body. Tear the second yellow paper to make the head. (Ducks should be different sizes.)
2. Cut umbrellas from 12" x 18" papers.
3. Cut narrow strips of tinfoil to make rain.
4. Cut green paper in strips of different lengths to make tall grass.
5. Use construction paper scraps for details (duck's eyes, beak, legs, umbrella decorations, etc.).
6. Staple on the gray background.
7. Staple on ducks, grass and rain.

MAY BULLETIN BOARD

"My Country Tis of Thee"
Get a march on May. (Grade 5)

WHAT IS NEEDED

1. 18" x 24" yellow construction paper (enough to cover the bulletin board)
2. 18" x 24" blue construction paper or 18" x 24" red construction paper
3. 9" x 12" construction paper – white, yellow, pink, brown, black, several sheets of each color per class
4. 18 – 3" x 5" red construction paper
5. Glue
6. Scissors
7. Stapler

WHAT TO DO

1. Discuss body positions of people when they march.
2. Discuss what different band instruments look like.
3. Assign student to different instruments, draw them and cut them out.
4. Select blue or red for the band uniforms.
5. Draw and cut out band members from the blue or red paper (brown or pink paper for the hands and face, black for the shoes and yellow for buttons).
6. Additional figures you may use are band leader, majorette and people carrying flags.
7. Cut out letters for **MY COUNTRY TIS OF THEE** from the 3" x 5" red paper.
8. Staple yellow background paper to the board.
9. Staple letters and figures as shown.

You will probably have more marchers than bulletin board space, if so, march them down the halls of your school.

JUNE BULLETIN BOARD

"Thank You" by Grade 6
A special thank you to all!

WHAT IS NEEDED
1. 18" x 24" dark blue construction paper (enough to cover the bulletin board)
2. 18" x 24" white construction paper
3. 8 – 3" x 5" white construction paper (per class)
4. Markers (wide and narrow tip) all colors
5. Scissors

WHAT TO DO
1. The students are going to draw full length portraits of the people who have helped them during their elementary school years (principal, teachers, secretary, nurse, cooks, custodian and parent volunteers).
2. Discuss body proportion.
3. Ask each of the above mentioned people to step into the classroom for 5-10 minutes. While they are in the room ask students to observe:
 a) hair length and style
 b) glasses
 c) clothing
 d) shoes
 e) bracelets, earrings
 f) watch
 g) height
4. Ask each student to select one of the people to draw. Use markers on the white 18" x 24" paper
5. Cut out the drawings.
6. Cover the board with blue paper.
7. Cut out letters that spell **THANK YOU**.
8. Staple up wards and people.

Conclusion

The information in this book will help you get off to a good start as an art teacher. Now that I have shared some of my teaching techniques and lessons with you, remember to approach the job with your own individual flair. Each art teacher faces problems unique to his school, budget and students. Modify these projects and ideas to suit your own personality and needs. Above all, foster creativity and help your students enjoy art.

Teacher Notes . . .